How Happy We Were

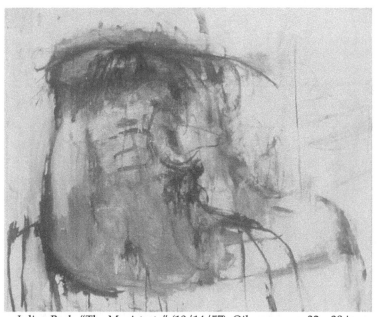

Julian Beck: "The Magistrate" (10/14/57). Oil on canvas, 32 x 38 in.
Collection of Fondazione Morra, Napoli.

How Happy We Were

a prison journal

by Julian Beck

with a Foreword by Tom Walker
and an Afterword by Garrick Beck

FAST BOOKS

Fast Books are edited and published by Michael Smith
P. O. Box 1268, Silverton, OR 97381

ISBN 978-0-9982793-5-0

Foreword
by Tom Walker

When I joined The Living Theatre in 1971, I not only joined a group of dedicated, industrious theatre artists, but a group of diary writers. Judith Malina kept a daily diary. She wrote everything down – productions, rehearsals, performances, life. She created directing notebooks. She wrote poems, including a poem written on every full moon. Julian Beck wrote journals – not a day-by-day account, but more often reflections on life and art, politics and culture. He was eventually to produce two meditation collections on theatre: *The Life of the Theatre* (1972) and *Theandric* (published posthumously in 1992). He also wrote two long poetry cycles, *150 Songs of the Revolution* and *daily light daily speech daily life*, among his many other single poems.

Julian's journals cover 1952 to 1965 and 1969 to his death in 1985. He kept copious notes in 1968 for the play *Paradise Now*. A youthful 1944 series was recently discovered in The Living Theatre Archive at the Beinecke Rare Book Library at Yale. The later journals were termed Workbooks and contain his production plans for the plays he began to write after 1969. Julian taught himself shorthand, and to read many of the journals, the scholar must learn this shorthand; Julian conveniently left a key.

Helped by longtime Living Theatre member Ilion Troya, I have begun transcribing selections from the sixty notebooks of journals Julian left, which we hope to publish with the help of the Fondazione Morra of

Naples, Italy, with its extensive Living Theatre archive, and the Beinecke. In the meantime, I discovered in my possession a photocopy of Julian's detailed account of the twenty-five days he spent in jail in 1957 with his *Catholic Worker* companions. We have not located the original, but the photocopy is clear enough. Julian corrected the many typos in pen.

Judith and Julian were dedicated theatre artists and also dedicated anarchist-pacifist political activists. They were leaders in the General Strike for Peace in the mid-1950s. Hence their participation with Dorothy Day, Ammon Hennecy, and the other *Catholic Worker* activists in refusing to take cover during simulated anti-air raid tests in New York City in July 1957. They protested openly in Sara Delano Roosevelt Park, across Chrystie Street from the *Catholic Worker*, were arrested, judged, and sentenced to a month in prison. Julian's prison journal recounts it all, based on hidden writings he wrote while actually in prison and further recollections and reflections in the following months.

In this lovely text, written when he was thirty-two, two years before he and Judith Malina opened The Living Theatre at 14th Street and Sixth Avenue, Julian Beck comes across as a lyrical, insightful, and tremendously committed artist, activist, and humanist. He is a keen observer of his companions, be they prisoner or guard or friend. He is not afraid to be self-critical. We learn from his passion and his humility and his moral example. Seventy years on, we are inspired by his vision.

Editor's Note

In summer 1957 Julian Beck, Judith Malina, and
a contingent from the *Catholic Worker* movement
were sentenced to thirty days in the workhouse for
protesting the mandatory civil defense drills and the
war machine they symbolized. Julian served his time
on Hart Island in the Bronx and at The Tombs in lower
Manhattan. (Judith was imprisoned separately with
Dorothy Day at the Women's House of Detention in
Greenwich Village.) Julian's experience was so intense
and intensely personal that he was impelled to record
it in writing, searching out the meaning. Events
kept outrunning his pen; thus he often circles back
to describe and reflect on earlier days. Once he was
home again, he found he had much more to say so he
returned to his journal, expanding his notes, deepening
his understanding. The looping, overlapping
chronology enriches the tale.

Julian's feelings were deeply stirred. The relatively
brief period he spent imprisoned shook him awake and
had an immediate, resonating significance in his ideas
about how to live. He felt duty-bound to communicate
what he had seen and learned. It is a great pleasure to
follow along, his sweetness everywhere apparent, as he
thinks and feels his way toward becoming the artistic
and revolutionary leader we knew and loved.

Michael Smith

How Happy We Were

<u>Friday, July 12, 1957</u> I am in a cell in a prison. Rather than go outside the moment and write about it, I will go into the moment and live in it: and write when the time of reflection is.

Now here in the cell[1] the conversation has ceased. There are eight of us, all here for the same offense: defiance of the Air Raid Test, defiance of the War Preparations. (Then perhaps I am not so much an artist if, in the middle of a painting, as I was this morning, I can participate in this kind of moral protest and risk my time for work and be in jail.) The sentence, which was dispensed about a half-hour ago by Judge Bayer, was thirty days in the workhouse. I understand we are to go to Hart Island. The only responsibility which will be interfered with by this is that we will not be able to visit Garry[2] during the visiting weekend at camp. I will write to him and try to help him understand. Truly that is the only thing that disturbs me. (The guard came and took away any knives, etc. — of which I happened to have one, attached to my father's car keys. I had forgotten all about it, indeed was never conscious of having it with me.) Otherwise I feel — I can't find a word, I've been thinking for five minutes — I feel bemused, I think. That isn't really the only feeling — calm, gay, and yet a little unsettled. We are waiting to be transported to the place where we are to be for the next thirty days. With me in this cell, which is wide and high and fairly clean and cool, are Ammon Hennacy, Michael Graine, Dan O'Hagin, Kieran Dugan, Sandy

1 A holding cell at the Bronx Criminal Court.
2 Garrick Beck, Julian Beck and Judith Malina's son, age 8.

(Frank) Darlington, Carl Meyer, and Richard Moses. Moses was arrested separately with his wife; it was quite amusing when he was brought into the cell and we discovered that he was brought in for the same charge. The women, who are in another cell, are Judith, Dorothy Day, and Deane Mowrer—and Joan Moses.

I have made paintings and poems and plays, and yet this is the most real thing I have ever done. Even my loving has been make-believe. But this act of love is real.

Time passes. It is an hour since we left the courtroom. There are spurts of lively talk, then one sinks back into a kind of solitude and reflection. There is much joking. Books are read: Herbert Read, pamphlets, Spinoza, A. J. Muste. Bits of information about jail life, letter-writing privileges, food, money, etc.

What is this life of art and principles? The question is, what am I? And the answer is, I do not know.

Today is a day without eloquence. When the reporter from the New York Post asked me for a statement, I could only fish for words, could make no cohesive sentence. And when we stood in court I could make no sentence in my head to speak out. It seemed so clear and obvious. Why did we do what we did? I did it because it was automatic. I cannot participate in the mechanics of war and the state. What good are the paintings if there is no love? I do this because it is an act of love and of faith in love. "The trouble with you," someone told me, "is that you think too much and about too many things."

Later We have been transported to the Bronx County Prison, apparently for overnight. Tomorrow presumably we will be moved to a permanent island prison.

This is a room, a cell about 10 feet wide and 14 feet long. There are bars along one wall, chrome benches along 1½ walls. There is a toilet, enclosed on three sides, and a mad sink. In order to get water to pour from it, one must press a button almost impossible to move. Since it really requires two hands to get the thing to work, all one can do is watch the water go down the drain once you have gotten it to flow. The prisoners learn to cooperate, and so one presses and the other avails himself of the flow. This sink is equipped with a fount which points downwards, but it is so designed that if one places one's forefinger on it, thus directing the flow backwards, it will spout upwards thru a hole designed for the purpose, issuing a spout like a whale, and so one may drink; however, the sink is against the wall, and there is no room for the head somehow, and thus there is a Tantalus among us. Earlier there were sixteen of us in the adjoining cell where we had supper: bologna (two slices), a braised potato, some beets, a weird viscous pudding which I could not identify, and cocoa. I traded my meat with Michael Graine for his potato. There were four slices of bread. It was filling but we had had soup for lunch at the *Catholic Worker* and it was so good.

But prison is a place to crab and complain about. There are seven of us in this cell: Ammon, Kieran Dugan, an old man (a derelict), and three colored youths. We have each been given two blankets. We

3

sleep on the concrete floor. Ammon sleeps peacefully, one of the negroes plays with his prick, and the old man snores. Overhead a 150-watt bulb, naked, glares. And the radio blares. For about an hour we had jazz, not even egghead jazz, which slammed its own sound against these tiled walls. Now the Brooklyn Dodgers ballgame is coming to us hard and loud. Modern humanism in a modern prison in which seven men sleep crowded on a concrete floor. I do not mind but I am surprised. We have been searched, though not thoroughly, and money and valuables have been removed. The blaring radio is grotesque. The ride here was also grotesque, in an almost entirely enclosed Black Maria, overly crowded, and hot, no room even to stand, and everyone handcuffed in pairs. That was a remarkably unpleasant sensation, and the instrument itself is so primitive, cruel, and unbefitting of use in this twentieth century since the birth of Christ. Judith saw me getting out, for she was in the rear compartment of the van, and we shouted questions and answers to one another of a practical nature: whom to call and would we be out in time to visit Garry, etc. The lights are out

A half hour later. Now I can see enough to write, but not enough to read (I have Spinoza with me). It must be 10 o'clock, long before my bedtime, my mind is active and I cannot sleep. I am glad of this paper which I brought with me. A week ago we were in Bonaventure, and the night before that I slept under the stars near Bathurst, New Brunswick. It was an incomparably beautiful spot, across the bay the Gaspé, above the stars and the

4

mysterious aurora borealis, like some huge lumia by Thomas Wilfred, an impossible miracle of light. Tonight it is an iron ceiling with the shadows of bars. Tout change, mon cher. Yet perhaps it is in this way that my life differs from the Eskimo.

A faint headache.

I assume that gallantry is such that the women are in more comfortable circumstances than we. I do not think I will be permitted to write Judith. I think prisoners are not allowed to write one another.

If I dwell on the discomforts of prison it is because I am amused by the foolish things of this world. Like an adolescent who wonders at the marvels of the turning universe, the galaxies, the seas, the natural phenomena and man himself, so do I marvel at the being of man, so mighty, profound, and miraculous, which can build a civilization chock full of material and moral pathos. It is a world of splendor and comic fallacy. It is like a superb pudding mixed with sand. That is what we must taste.

The old man wakes and takes the end of my cigarette.

<u>Morning, July 13, 1957</u> I did not sleep well, I who usually sleep so soundly. But I was not cranky. The night resounded with the expected night noises of snores and coughs and clearing of throats. We awoke at about 6 a.m., I guess, splashed ourselves with water, and were served the most dreadful and unpalatable breakfast I have ever encountered. A dry cereal called Pep in a bowl of powdered milk and no sugar, overly

5

sweet coffee with the same artificial milk, and bread, dry, with stewed-to-a-pulp apricots, unsweetened and a trifle burned in the stewing. Alors, this is tolerable, or at least one gets used to it. I keep giving cigarettes away and will soon run out of them. I hope this will serve my project to rid myself of that habit which I do not admire but condone. It is an overcast day, warm and muggy already.

Judith and I had discussed participating in the protest against the air raid drill but had come to no definite decision. Thursday evening, while we were entertaining Dollie Chareau and Reva and Albert Urban[3], Dick Kern[4] called and said that the drill was to take place the next day. I called the *Catholic Worker*, and Ammon called back, telling me that they at the *CW* planned to protest by sitting in the park there on Chrystie Street, that there were four of them and two outsiders. By drill time the number was increased to ten.

We met at the *Worker* office at 12. The atmosphere was cheerful and busy and amidst the hubbub of the office there was time for jokes and jibes. We lunched downstairs and were each given a sandwich made especially for the purpose of taking to jail; they were neatly wrapped in wax paper and bound with rubber bands. We waited there till 1:30, when we went into the street and park. There were reporters and many police. The entire procedure was dignified. A reporter

3 Dollie Chareau was a translator and art collector. German artist Albert Urban and his wife Reva ran Gallery Urban on East Tenth Street.
4 Experimental filmmaker.

was truly friendly and in sympathy, wished us well, and said, "God bless you." The police, up until the time we were brought here, were all kind, pleasant, almost sympathetic, one especially, who rode with us from Elizabeth Street station, where we were first brought (and booked), to the 151st Street courthouse, where we were tried. He was especially friendly, gave us advice and helped morale.

In the courtroom there were two lawyers, a man and a woman from the Legal Aid Society. The judge, Magistrate Bayer, immediately appointed the man to speak for the men, the woman for the women. The lawyer spoke to us for only a few seconds, it could not have been more than thirty, and then gave a very fine little speech, a few sentences explaining our position which I found quite adequate. Ammon read a prepared statement signed by the four CWs. Dorothy said something about penance for dropping the bomb at Hiroshima and Nagasaki, Dan O'Hagin said a few words, and Mike Graine read a long poem about love and war which he had written. Then the judge spoke. At the beginning he had been incredulous, but when he spoke now he was angry. He referred to the fact that we were contemptuous of law and order and the state, and that this contempt we were hiding behind the guise of religion. I am not in sympathy with you, he said, and I hereby sentence you to 30 days in the workhouse.

Now we are waiting to be moved to Hart Island, and perhaps I can read some Spinoza. It is raining hard, and there is a feeling of tiredness and ennui hanging over everything. Except that I am very curious, every action,

every detail interests, probably because there are so few of them.

<u>Wednesday, July 17</u> Here we are sealed in. There is no window, no evident aperture connected to the outside world, no air, yet air mysteriously sifts in through vents in the ceiling. The only visible materials are stone, tile, steel, and glass; glass brick permits the dim light of the sun to filter into this room, there is no view, no evidence of an outside world, it is like a tomb; indeed it is the Tombs, the City Prison of Manhattan.

I have not been able to write for the past five days because I had nothing to write with; the paper I had brought was taken away, and I was fearful of having anything I might write confiscated. This is written on the flyleaves of the *Information Please Almanac*; I ripped out the leaves with only the slightest compunction. And I am relieved to be able to release some of my impressions and reactions from my mind. It is true that this may not be, but I am leading myself to believe that it is, an important time.

We left the Bronx County Prison on Saturday morning. We were herded into one of the Department of Correction vans. The rumor was that we were being sent to Hart Island; but of course there was no certainty. Uncertainty is one of the characteristics. The vans are really prisons on wheels and are designed as such. They are dark, uncomfortable, and poorly ventilated. The prisoner can see out, though he must strain to do so, but the people outside, the free men, cannot see in because of the fine strong steel mesh screen. It got very

hot inside, for it was a muggy day and drizzly. Ammon and I and four others sat in the smaller rear part of the van usually used for ladies. We quickly were friendly, and whatever information anyone had was quickly passed on. Judging from the route the van was taking, we were going to Hart Island. Hart Island is located in Pelham Bay, a ten-minute ferry ride from the shore of City Island. We griped about the heat, and while we rode across the water my mind entertained unpleasant fantasies in which there was an accident and the locked van sank. I understand that there are even laws against transporting prisoners over water either shackled or in a locked van; but I am not interested in the law. Each day I become less interested and more and more convinced that one day the good sense of free men will make all law superfluous. Even traffic laws. Law is a manifestation of man's need to invent an instrument to inflict castigation upon himself, to satisfy his need to be punished, to be a prisoner, and thus through the law, man is a prisoner in his own society.

We were relieved to get out of the van and found ourselves on a pretty island with pink institutional-looking buildings, lawns, and fine trees. Ammon had told us something of what the induction would be like. You strip naked as a baby and they look up your ass and take away all your clothes. The hack in charge was brutal in tone and effect. The others were mild, and one was quite kind. It was he who looked at the notes I had made and said, "I'm not going to read this and I'm not going to ask what it says," and he put it in my property envelope to be kept for me till I am released. We were

asked by these guards why we were imprisoned, and we answered honestly and well, I think. They did not disrespect us. The kindly one recognized Ammon, and when told that he had returned for the same crime, said, "They can't teach you a lesson, can they?" We both replied, "We're trying to teach *them* a lesson." The vicious hack looked at Ammon's two copies of the *Catholic Worker* and harshly tore them up. Through all this I was trembling, but very faintly. I bantered with the guards and spoke politely, trying to communicate goodwill and likableness. I wanted the hacks and my fellow inmates to look on me as likable. I enjoy being liked, and I get a kick out of being good. I try not to be obnoxious, though I fear I am, and I try to practice the virtue of good cheer. We were told to undress. It was terrifying. A gang before us on the other side of the room had already submitted and gone through the ordeal. They were about thirty in number, a vanful like our own, and we had watched. I gritted my teeth and looked away to keep from becoming ill.

I became ill, or trembled on the verge of becoming ill, not because of anything that was being done to me, really, but rather because of what I saw, and because I could not control my feelings and sentimentalized and imagined that I knew what the old men, the derelicts, the broken vagrants, were feeling. I have no idea of what they were really feeling, but it was terribly painful to me to see them forced to undress and submit to the loud orders, the bullying orders of the screws. The screws had no choice, they are not the judges, the old men had been sent to them and they must order

them — that is, put them in order, help them, clean them up, care for them in a large and complex institution. The behavior of the screws in general is, was, mild yet dreadful, understandable, forgivable, yet without, utterly without raison d'être, basic, useful, human, worldly raison d'être. It is that they live devoutly in the service of Mammon.

Thursday, July 18 We awaken, or are awakened, as the case may be, at 5 a.m. I have washed, dressed, folded my bedding, and am lying now on the raw steel springs of my berth waiting the call for breakfast, or "chow" as it is called. One is awakened in a very gentle fashion: the lights are turned on, this is followed in a few minutes by music from the radio, a few minutes later the volume is increased. Somehow or other this contrasts sharply with the alarm clocks of the outside world with which I was familiar. At Hart Island a whistle was softly tooted before the radio was turned on, but it too was without the damned annoyance of the alarm clock. Now, it is perhaps easier to awaken in prison because one goes to sleep earlier than one does outside. On Hart Island the lights were turned out at 9 p.m. — here in The Tombs[5] at 10 p.m. Since I tend to err in the direction of ascribing causes to psychological rather than physical background, I always preached that the alarm clock agony was a result of our discontent with the world to which we were awakening, not to lack of sleep. Yet here in prison, surely, one should be discontent with the

5 The Tombs is the colloquial name for the municipal jail at 125 White Street in lower Manhattan, to which Julian had been transferred.

world to which one awakens; or does one here wake up easily because one is afraid to sleep, as if afraid of some nameless punishment levied for not getting up? Perhaps one rises easily in prison because in prison you do without hesitation whatever you are asked to do. Soon I will go to breakfast, well prepared, I do not have to make coffee this morning, or rush out of the house, or help Lester[6] to get some breakfast before he leaves, I can eat at my ease, I am without responsibility. Let us say that I do not know the reason why the inmates rise easily in prison without complaint (this is one thing I have heard not a single complaint about). Yet, nevertheless, I rise here feeling fresh and with ease.

Returned from breakfast, the astonishing fact is called to my attention that in The Tombs it is not necessary to get up until 8 a.m. unless you have an assignment for work that starts before then. Indeed, even now I can see a few prisoners lying in bed. I had noticed them before breakfast but had assumed that they had a kitchen detail and worked late washing dishes and cleaning up, but such is not necessarily the case at all. On Hart Island one did get up on time, everyone. Yet there is an uncanny aura to the entire experience and to the atmosphere of prisons. No documentary film has ever photographed it. That can't be done. Official facts do not betray it. It is not in those facts. It cannot be seen, it can hardly be felt, yet it certainly is.

6 Lester Schwartz, a shipyard worker and (per Wikipedia) shared lover, lived with Judith Malina and Julian Beck on West End Avenue at this time.

<u>Later</u> Too unnerved to write. (Yet I write.)
Too disturbed. I am tired and a little frightened by
the situation in which I find myself. I am trying to
minimize my reaction. I don't really quite know what I
am feeling. I cannot analyze it at all, but I suspect I am
on the verge of hysteria. Today everything changed. I
was transferred, and prison life really began. There are
various levels, I find, and there are lower and higher
ones than the one I have now reached. I am tired, very
tired.

<u>Friday, July 19</u> I sleep in a new dormitory on the 11th
floor, and I work with The Help on the 6th floor tiers.
This is a thing in itself, this life in this setup. How shall
I describe it, where shall I find queasy enough words?
The events take place rapidly. Though I have already
experienced boredom during this past week, prison
as I know it is not uneventful. But this first week has
been busy as all first weeks are while the prisoner is
allocated and becomes adjusted. My thirty-day sentence
is so short a time and the experience so new. I am a
sensitive observer and aware of too many details. I am
not suffering, not at all, not at all, but I am disturbed by
what I see, and while I am now quite sad, the experience
is one of the most positive I have ever had; and while
it is apparent in the outer world, where everything is
beautiful and good, that the soul of man is sick with
cancers, here, where everything is ugly and corrupt, it
is obvious that the souls of men abound with goodness
and the antidotes to all pain.

<u>Later</u> A few free moments, for I work from 6 a.m. to 7 p.m., a thirteen-hour day, and though there are breaks, the work is fairly continuous. I am one of six prisoners who service — feed, serve, clean the cells and walks of, tend, etc. — 180-200 other prisoners here in the tiers. The Help are not supplied with any chairs. Do they expect us to stand for thirteen hours a day? Surely it is understood that, in uncivilized fashion, we sit on the floor and garbage cans and food wagons as I am now.

Ah yes, Hart Island, the induction: one is searched, one's properties are confiscated, you turn your pockets inside out, the guard runs his hands all over you, feeling the cuffs of your trousers, your tie and collar, the lining of your coat, etc. All of which seems a bit absurd since one's clothing is taken away in a matter of minutes.

<u>8:30 p.m.</u> In the dormitory. I have isolated my panic. It is part of a play within a play, a part, a well-known part of prison life — indeed a well-known part of life, and one with which I could, can, easily cope in the outer world but which I am confused by here. I can admit at least that I have never liked love affairs in phone booths or the backseats of cars or in men's rooms or in the bathroom while a party was in progress, and indeed I have never had sex under that kind of circumstance. Imagine then the terror that overcomes me at the insistent and numberless overtures of my fellow inmates. I am plagued by them. I am fearful of arousing hostility, and therefore "no" is a difficult thing to phrase. Many of the advances come from colored prisoners, and

consequently when I refuse to accede to their proposals, I am accused of racial prejudice!

I should continue now with the story of the induction, which I have started at least three times, but it is more important now that I write some letters. #1 to Garry, #2 to Franklin[7], and #3 to Lester. Indeed I do not yet have any writing paper. I have been without money since it was taken away at the Bronx County prison. Red tape is the problem. Therefore I've been unable to purchase writing paper, and therefore unable to communicate with anyone. But now that I am settled, as it were, I've been able to borrow paper and envelopes.

<u>Sunday, July 21, 6 a.m.</u> Last night we worked late, for there was trouble with the plumbing and no hot water. We did not finish till after 8 p.m., which was a shame, because it was our night to go on the roof for recreation. It had been more than three days since I had seen true daylight, had seen anything but the steel and tiles and cement and glass brick. The sky and fresh air were so wondrous, so good, the color and taste and smell of them, and above all the meaning. The roof on which we were is the top of a wing of the prison. A high wall, 10 feet about, surrounds it, and top is completely enclosed by a steel cage affair. But the tent of blue with three gaudy little pink filigree clouds was visible. The intensity of my feeling of gratitude is absurd and perhaps overwrought. When Kieran Dugan

7 His brother.

showed me how from a corner of this terrace, the tower of this building, the dome, gold, of another building could be seen, my glee was immeasurable. These reactions must seem a trifle intense, but it is my nature to enjoy that kind of rapture. The reaction is a bit too poetic — if you are on the outside. Here there is so little of that nature to react to that the smallest thing — not being able to see the sky for three days or to smell fresh air in July — becomes a major gap in experience, and when the gap is filled and you go on the roof and see the sky, it blinds your eyes, the light is so intense that for fully ten minutes I was aware of my eyes throbbing and in pain. This I never imagined nor would have believed before it happened to me.

This record somehow omits one of the most important elements of this sojourn. I concentrate so much when I write on the dramatic and subtle horrors of these places and events, on the sorrow and pity and points of despair, that I omit the most impressive, really the most impressive aspect of prison life, and that is the good cheer. Everyone is cheerful, everyone is helping everyone else to bear it. Oh, there are a few exceptions, and they are sad, but no one gives them up or avoids them. Everyone is cheerful, and that is so wonderful that one wishes the world at large would emulate the inmates of prisons.

Before I proceed with my narrative and continue my description of Hart Island and the induction, I must give tribute to the seven men and boys with whom I was first imprisoned. For each one I have come to have love and admiration. With what joy

we passed those first days at Hart Island together, what jollity, what spirit, what goodness. Each one has been gifted with some wisdom, each has a wisdom slightly different from the other, but each has it. The congeniality was remarkable, though perhaps natural, for do not people under adverse circumstances always help each other? — whereas they seldom go out of their way in daily life. Indeed, being locked up with these people on Hart Island for five days made for five of the pleasantest days I have ever spent. And in a way the first days are the most difficult, because one is frightened and a novice, inexperienced and insecure. We bolstered one another's courage, sped each other on with jokes and sly snide commentaries and the perennial marvelous good cheer.

The Induction: I have another hour free now till I must go back to work. I sit here in this dimly lit kitchen on a table. (The room is about 7 by 12 feet in size and contains a great deal of equipment, but it is functionally quite well designed.) The old men seemed so confused and full of panic when the guards forced them to undress. Their shame was great and the intrusion into their privacy was almost more than they or I could bear. One of them wandered aimlessly and crazily away trying to avoid the kerosene spray which would be aimed at him shortly. Another began whining, and the guards yelled louder. I know that I was embarrassed for my own sake and felt self-conscious about undressing for the guards, and I pitied the old men, but perhaps I pitied myself more. This was the moment at which I felt most defenseless and

most humiliated.

The first to undress was a large negro about 6'3"
in height. His entire left side starting at the back of
his shoulder and down to his toes was covered with
running sores. It was so insane that for a moment I
thought they were sequins. The density of the sores
increased as the thigh ran into the calf to the ankle to
the foot, all swollen and covered with maggots. Some
of the spectators giggled, some of the old tramps
giggled in disgust. And one, whose complexion
resembled nothing so much as a cork and whose
features looked as if they had been carved by an idiot
from a coconut — the one who wandered aimlessly —
was so covered with dirt that when he emerged from
the shower the dirt peeled off him in sheets like the
outer paper of an onion.

We followed in their wake, our clothes were
taken from us, and we were sprayed with kerosene,
showered, and given clothes. They were not far from
being rags: torn gray shirts with short sleeves, gray
pants, undershorts, socks, a belt, and heavy black
shoes. Needless to say, none of the clothes fitted,
but I was happy that they were not stamped with a
stencil saying Dept. of Correction or some such. A few
possessions we could keep: a comb, two pencils and
cigarettes, half a pack of cigarettes which I had. These
I put in my back pockets, of which there were two. The
pants are notable for the fact that they have no side
pockets; for the first two days one is constantly trying
to put one's hands into pockets that do not exist. It is
amusing and laughingly frustrating. (The clothes are, I

am told, made by inmates in the upstate prisons.) Also one keeps looking at one's left wrist for the watch that is not there.

Clothes were being given out by inmates, and from certain mannerisms I was quickly aware that they were shrewd operators and were equipped with cigarettes, candy, handkerchiefs, clothes that were not torn and that were well-fitting. They seemed confident and were condescending towards the recruits. The vicious guard, surly and fat, kept hollering go here, do this, do that, sit down, stand up. His turn will come. After we were outfitted, we were fingerprinted. This had been done to me in 1943 when I worked for the Reynolds Metals Co. I resented it then and I do now. It is as if one's privacy is being eternally stolen, one's identity classified and filed.

It was then about 1 p.m. We had had breakfast such as it was about 5:30 a.m. We were hungry and were very pleased with the soup we were served. There were meatballs in the soup, and Ammon and I gave them away to grateful comrades. We both agreed that the soup tasted extremely good, and the reason was that it probably had a meat stock. This amused us very much, Ammon and me, we are both quite scrupulous in these vegetarian matters.

After the soup we were given cards and numbers and locations. Young Carl Meyer, twenty years old, was separated from the possibility of corruption by being sent to an isolated cell. It was a Saturday, and so he could not be transferred. On Monday he was, we think, sent to a juvenile dormitory on Rikers Island.

We, the remaining six, were sent to Dormitory #10, a large dormitory consisting of two connected rooms, about ninety beds in one room and about forty-five beds in the other. There were heavy screens on the windows but no bars. The doors, however, had large and heavy bars. The beds were double-decker. All of us but Michael Graine chose uppers; he seemed to be afraid of falling out. I had a berth right next to Daniel O'Hagin, who in turn was net to Frank Darlington. Kieran Dugan was across the room, and Ammon and Mike next door in the larger of the rooms. We were given four blankets each, all clearly saying Department of Correction, two small coarse muslin cot sheets, a white towel, and a muslin pillow case and a horsehair pillow. One sleeps on the spring of the bed, there is no mattress, one simply covers the springs with three blankets folded double and goes to sleep. In fact we got into the dormitory and that is what we all did.

When I awoke about an hour later, Dan had found the book pile and had brought a book back for me. The caliber of the books was fair, yet, since I was not interested in fiction, the best I could find was a book describing China, *Changing China*, an historical, geographical, political, and social study, informative and therefore interesting. I don't know who wrote it because the title page had been torn out. The tearing out of fly leaves and title pages is common because of the unavailability of paper. Everything in prison is hard to get, even when the item may be obtained from the commissary. Cigarettes are absolutely at a premium. What shocked me, strangely, was that no one seemed

to care whether or not one had a toothbrush and toothpaste. In fact I am still without them. After a few days it occurred to me to take some salt out of the mess hall, and then Dick Moses gave me the idea of using the terry cloth towel to rub my teeth with.

<u>Tuesday, July 23</u> I discussed the toothbrush business with Kieran Dugan last night and we both agreed that we had gotten quite used to being without a toothbrush and paste, that salt and one's finger or the towel were more than adequate, that our devotion to the toothbrush is a result of insistent advertising. Goodbye to the toothbrush.

A shakedown is going on now.

<u>Wednesday, July 24</u> The days go quickly but the weeks go slowly. Whatever free time I have I spend writing letters or writing here. Here at The Tombs there is little reading matter that I am really interested in. Elizabeth Bowen's *Look at All Those Roses*, some Thomas Hardy short stories, a Graham Greene novel, some pre-Shakespearean Elizabethan plays, and Newman's biography of Wagner. If I had a Bible I'd go on with that, but I can't seem to get one. I might have, last Friday, gotten one from the rabbi, but he was so dreadful that I didn't even want to talk with him. And besides, I can read when I leave here. While I am here I want to stay with it. I don't need frigate books.

<u>Thurs. July 25</u> This morning I didn't even know what day of the week it was. In one way each day is exactly

the same as the next; there is no difference whatsoever in the routine; yet since the smallest detail is of interest and makes for universal excitement, each day has its unique events to make it memorable. But, of course, I am here for so short a time that my position is not so bad, and my personality and interests make my relationship to it unique. Everyone else here is subject to it, is experiencing it, whereas I am observing it. It is, I think, a huge difference, perhaps an advantage; but, remember, even my observations are partially unfelt in truth, for I am not feeling things like the real prisoner.

I miss Judith, I am so anxious to be with her, to hold her little body close, and to talk with her and to tell her what has happened to me and to learn every detail of what she has experienced. I wish I could stop worrying about her welfare, for I'm sure she's all right, I'm sure she is reacting much the same way as I, though I know she is thinking thoughts more perceptive and extensive than mine. I have come to recognize that her thinking is among the most creative I have listened to. So I long to hear her thoughts. Also I very much miss seeing the outside, some light, some sky, some air — I'd like some fresh air, and some people walking.

The most exciting part of the day is mail call at night. I have gotten few letters so far. Last night I tried to control my eagerness for mail, and I succeeded; I took myself through expectation and disappointment to a calm state of pragmatic tranquility. As a matter of fact, there were three letters last night. One from Judith,

one from Lester, and one from Robin Prising[8]. The last
was a florid note of praise but I liked it rather. I worry
about Lester, especially when Judith writes that he is
drinking again. As I feared, he is faring worse than
either Judith or I. We are having an adventure, but he
is having nothing. I am not bored nor angry, but we
were the forces of his life, and he is probably bored
and angry. Nothing that happens in the prison really
emotionally disturbs me; it is outside business and
personal matters that are upsetting. I note that this is
true of other prisoners; those who are worried about
wives and installment payments, jobs, etc., girlfriends,
these people are in a kind of anguish; the others are
much more calm.

I miss music. There's a lot of singing here. I sing a
lot: I've never in my life been in control of such a good
voice. I have gone through the repertory of all the tunes
I know, just about, operatic and symphonic, popular,
folk, and nursery tunes, tunes sentimental, hymns,
everything, as I go about my work.

Though my first description of the waking-up ritual
was accurate at the time, things have changed. Indeed
the whole character of prison has changed as I become
more and more acquainted with it. Where I am now, I
work thirteen to fourteen hours a day. I am living with
a group of inmates who do the same work I do. There
are about thirty-eight of us who are known as "The
Help." There are five or six to a floor, and there are
seven floors. I am on the sixth. The dormitory is small;

8 Actor and peace activist, board member of the War Resisters League.

we go upstairs about 7-7:30 or 8 at night. Lights go out at 10 p.m. We are awakened at 5 a.m. Everyone is sleepy and drags himself from bed. There is absolutely no complaining. The lights are turned on, and the hack wakes up everyone by walking around and shouting. The hack in charge changes just about daily. One of them, a good-looking young screw, savagely blows his whistle. It is like being awakened by a scream. There is no slow-poking about, you have barely enough time, it seems, to wash and get into your shirt before your floor is called and the hack is waiting to take you there. In a stupor one rushes about setting up and serving breakfast. After the 200-odd prisoners have been fed, then we eat and not before. If the screw catches you sipping coffee or munching bread, he may refuse you your breakfast. Somehow one does sneak a sip of coffee, but it is very nervous-making. I wanted romance, I wanted adventure

Hart Island again. The first night, Saturday, July 13th, we march in twos to the mess hall. Not really march, for we amble along, the line wobbles and wavers, and no attempt is made to step it up or make it military. The screws are constantly counting the men. It would be very easy to escape from the island. There is no wall around it, no patrol, and if one were minimally clever, one could slip away and swim to the mainland or to a boat. Attempted escape automatically means one year added to sentence, and since the longest sentence on the island is six months, I'm sure it is never attempted. I suppose one does risk drowning also. Have I mentioned that all the buildings, which

are of brick, have been painted a pretty flesh pink, and the trim, lintels and steps, etc., white? There are lovely hedges and elms and sycamores and even a fine beech tree, and several evergreens. Except for the heavy screen on the windows and the bars and the monotonous clothing of the inhabitants, I recommend it highly as pleasant to look at. As I got to learn, it has two functions: it is a clearing house for minor offenders with light sentences, and it is a rehabilitation station for the kids. I noticed that above the mess hall door a date was inscribed. If I remember correctly, it was 1885. It was built as a home for NYC's homeless, during the war years it was used as a navy prison, and, now, its present service. The island also accommodates Potter's Field, and I am told that we may be assigned to graveyard duty: we may have to dig graves. Burying takes place on Tuesday and Thursday. Large trenches are dug 14 feet deep.

Friday, July 26 Prison, like life, has its disappointments, and I come to realize that I must after all accept this act that I have performed as itself, of itself, and for its own purpose. That is, the act exists without me, Julian Beck, I am not disappointed in the friends who have not written, nor the newspapers that have not fussed. I realize in my longing for mail which does not come, for celebration that is not there, that I must accept the impersonality of such acts if I am to perform them again. They must be selfless and one must be utterly selfless to perform them satisfactorily. As long as I yearn for success and attendant attention I can only call

it failure, the small attention I shall get. But as I move toward the selfless acts, the real satisfaction becomes greater and in my own heart more enduring. I feel awfully lonely tonight, yet I have miraculously gone through it, and I believe that here in this wretched hideous monstrous building I have come to my very first victory. I close my eyes and see lilies everywhere, and olive, and open them and there are the sweet sad faces of the thirty-five odd men whom I need and who need me. Perhaps cards, or some talk, or some fun, or some confidences, a candy bar shared, or silent exchange of some kind of friendliness. We bolster each other, all of us whose lives are not beds of roses or even primrose paths.

Saturday, July 27 This is the day we were to have visited Garry. I had two notes from him. "Even though you can't visit me, can you ask Lester or someone else to visit me. From Garry." They arrived too late for me to have done anything about them, and I don't think I could have asked Lester anyway to make such a trip. But today that preys upon me. How I could possibly imagine that Garry could accept this thing with real maturity I don't know. In part it may be that I gave myself a false picture of myself at the age of eight being more mature than he; or possibly he is less mature than I for his age. In any case he has reacted realistically like a child. But I foresee so little.

I have a cold
During the last half day it has become increasingly clear to me that while I am here in prison it is

incumbent upon me to do whatever I can, clumsily or not, to offer friendship and help to the men I am with. Let the writing and the introspection go. I am here so short a time. Forgive me, but as usual, I find myself well-liked, popular, and above all, a desired listener. The latter is probably a result of the sympathy and understanding I give to the tales told. I help in the writing of letters and in composing them, and this is in addition to the favors I can perform in my capacity as trusty.

<u>Sunday, July 28</u> That little aubade which I wrote the other day on the pleasures of awaking in prison was composed under the veil of an illusion. Or let me say that what it hymned is no longer the case. Not where I am now. Here we work thirteen hours, or fourteen as last night, the lights go out at 10 and on again at 5 a.m. The hack goes from bed to bed tapping the feet of recalcitrant risers who drag themselves to their morning ablutions. There is no music and sometimes a murder whistle. On the tiers the hacks savagely blow whistles, once, twice, three four five times. OK guys, up up up. The lights go on, the whistle fiercely sounds again, and every nerve in my body recoils.

<u>Friday, August 2, Hart Island, Dormitory #6</u> We were transferred here on Tuesday, and I am extremely grateful for that, for it is far more comfortable here than at The Tombs; and, I am happy to report, despite my desire to atone for the sin of being a citizen of the first nation to drop an atom bomb, I am still quite human

enough to prefer a view of a bay, sunlight, and trees to the unnatural and sterile and sealed-in atmosphere of The Tombs. As a matter of fact, were I not grateful for the change, I should then have to doubt whether or not I were suffering at all. Did I not prefer it here to The Tombs, my being in jail would be nothing more than a lark, an adventure. And it is more than that.

When I first arrived on this island on July 13 and for the succeeding days until I was transferred to the City Prison, Manhattan, I had plenty of time to write but no paper. After the transfer I had plenty of paper but no time. That's the way life is sometimes. Ah me, I am a novice. In prison one never says, "I have no time." Everyone in prison has time, from one day upwards. "How much time did you get?" "Thirty days, ten days, ninety days, six months, one year," etc. "How much time have you left?" "Twelve days, eight days, seventy-six days." In the outer world, of course, the problem is quite opposite, for there no one has any time, no time for anything. "I'm sorry I just don't have a minute . . ."

Thirty days in jail is not boring. Not at least as I have passed them, or rather as they have been passed for me. First, the number is reduced to twenty-five, five days being deducted for good behavior; and, then, the fact that during my particular stay I had my location changed four times has greatly contributed to relieving anything like monotony.

<u>Saturday, August 3</u> Three weeks have passed since I first set foot on this island. I still remember with some peculiar horror the receiving station with its astonishing

assault upon the self. It is there, as one is pushed into the showers, that the first real moment of realization comes. At that moment a really perceptive person — and we are really all perceptive, and that is why the moment is ghastly — realizes that his body is being surrendered for keep to others; one is now chattel, a prisoner, an organism that is locked in, counted, and subject to cruel and unusual punishments, always under surveillance, and always compelled to obey a pattern distinctly not of one's choosing. This realization comes to everyone at this particular point, not in the locked van, not when the judge pronounces sentence, not when one is first handcuffed, but when one's personal possessions are confiscated and, like a slave, one stands naked before the guard listening to jibes and insults and answering questions. Yesterday two old men, skids, died during the receiving process, one instantly in the showers, one shortly afterwards. Horrified, rather, terrified, I sought further information, and all I could learn in addition is that "Oh, it happens all the time. Three guys died this week."

When I first heard that the island was the burial place for New York's unclaimed dead, I made an arpeggio of the words; and this, ferryboat and all, and locked box in which I traveled, became the Isle of the Dead. And here on this island, house of the dead and damned, I have come to have more hope and to experience more love among my fellow men than on any other part of this earth. It is a beautiful island.

Each detail is exciting. All of us — I speak particularly of the pacifist group, all of whom,

excepting Dan O'Hagin, have some literary bent—are observers. That is, we not only experience, but we observe also. Actually we observe more than we feel, and consequently whatever does happen to us and whatever we do report is not altogether authentic: it is filtered by the eye and heart that is not subject only but stands aside watching and commenting. This is at once a boon and a disadvantage. It mitigates any suffering, but it also lessens the validity of the experience. I can never feel as the true inmate feels. But then, I never feel as he feels about anything.

Though I write now about events past, though I am writing in retrospect, I am following a series of brief notes I made day by day. If I lapse into the present tense or even affect it, it is only as an aid to myself: I am not seeking a literary effect. This is still a journal. Anyway, one can never lie about time.

Saturday, July 13 We line up in twos. The hack cries, "On the count!" and one lines up to be counted. He cries up, "On the chow!" and one lines up to go to eat. As one leaves the dormitory one is counted. As one enters the mess hall one is counted. The walk from the dormitory is short, but one can see the shore of City Island and all the surrounding sweetness of nature, and the hedges nicely clipped, the lawns, the Catholic chapel across from the mess hall looking very expensive, built more for proselytizing, it is obvious, than for the greater glory of God.

The mess hall is so arranged for function that one enters through a corridor which is lined on both

sides by the dishwashing section. You pick up your meal tray, soup spoon (no knives, forks, or teaspoons again until you are released) and metal plate, which is stamped into three sections—a tin blue-plate. The deafening clatter of tin dishes being washed attacks you. Your nerves fly apart in several directions seeking escape, and the stomach automatically closes, knowing that this is no atmosphere in which to digest food properly. Hilarious signs are much in evidence reading "Quiet."

A line of inmates serves the food, and they are quite partial to giving large portions if one requests an extra dip. If I remember that first dinner correctly, it consisted of beans with bits of broken meatballs in it, cole slaw, a small tin dish with one half of a canned peach in it, four pieces of white bread, and a tin cup containing what will henceforth be referred to as coffee. I ate large quantities, and though I have not been on a scale, I believe I've gained wait during my stay.

At first I found the food vile beyond description. I was extremely conscious of the coating of grease on all the tin dishes; the food all had a grossness about it in appearance and taste; the vegetables were almost all poor grade canned things; the seasoning in the complicated soups was meager and salty; everything suffered in the cooking and was either over- or underdone, washed out or haggard with salt, greasy or watery. At the sight of the shapeless stuff (everything has the general texture and consistency of string beans cooked for several days, everything, pasta, puddings, even soups, though, of course, they have water added)

I even gagged a bit during those first meals. Breakfast was really painful the next morning: a few grim prunes, a box of cornflakes and a bowl of powdered milk and another cup of that mixture of coffee grounds in water. It is remarkable that something so hideous can be made of a mere coffee bean; but I guess if it is really an oldish coffee bean and is not really sunk in hot water long enough, if extra water is added so that even when black the mixture looks like medium tea; if, to that, artificial milk is added and then sugar (or possibly corn syrup), if then the whole thing is allowed to stand an hour or two before being served, the proper effect can be achieved. My first meal at The Tombs, though, was really staggering, because there the coffee was so vile that I marveled that in this Golden Age of Civilization even prisoners could be so maltreated. I learned later that it was not coffee at all; it was supposed to be tea! The truth is that it tasted like neither, it was brown and warm, its taste unique.

The insidious part of the whole food business, however, is that one adapts to it, one gets to like it, it seems quite satisfactory, gruesome bread puddings and unspeakable things that pass for lentil soup or spaghetti taste quite good, one forgets all about the greasy plates (I recalled them now only because of my notes), the noise is nothing, and the snorting and spitting and guzzling and drooling of one's fellow inmates is obviated by one's self-protective devices. At this writing, I am a little hungry, and look forward to breakfast and to the coffee. Somehow I have created the wrong impression. The food is edible. The meals

are balanced. The portions are usually large. The chef, at least the one here at Hart Island, is, I have since learned, anxious that the food taste as good as possible. Cornflakes in powdered milk without sugar will never taste good. (Monday morning I brightly dropped some of my jelly into the cereal, and it was greatly improved. I quickly taught this trick to my friends and to others through the hall, though many old-timers, of course, were familiar with it.) The food is simply of a kind that one cannot buy at any restaurant except perhaps one in Canada. Actually it is not that unusual, but it is hard at first to accept the idea that one will be eating no other fare for some time to come. Once the adjustment is made, the food is quite satisfactory. The meat-eaters miss good meats, steaks, chops, special fish, fancy cooking; the vegetarian misses the palate-boosters, and, I, eggs and cheese, also. There are no breakfast niceties. But then, none of these things are expected. Prison is supposed to be grim. During those first few days at Hart Island I was so happy in the company of my dear friends and in the pleasant landscape and seascape of this island that I wondered how my Catholic friends, who must be feeling what I was feeling, would ever believe they were doing any penance for our dropping of the first atomic bomb. I searched for the grimness.

The time one is to serve, the time of your life that the state takes from you as recompense for the crime you've committed, this is the real grimness. When the judge states the sentence — five days, thirty days, ninety days, six months, one year, five years, ten years — one is momentarily staggered. One adjusts to this soon

afterwards — during the first week, I am told.

(The Puerto Ricans are eyeing me now, a group of them. When they talk about me their dark eyes all stare, and when I glance over they wink as a group. Tonight I will be awakened. They are planning something.)

We finished our meal and returned to the dormitory. During these first days I kept considering my position, what I had done, but there was yet no distillation. That was to come. Now everything has resolved itself in words at least, and at least the words are clear.

<u>Sunday August 4</u> The word just came. The clerk just came and signaled to me that the typewritten slip had arrived with my name on it and that tomorrow I go home. Dick Stryker said that when he was serving his prison sentence at the Federal Penitentiary at Chillicothe, Ohio, one was awakened early in the morning of the day of one's departure, and that of course he was awake before he was awakened. He waited tensely for the footsteps and feared that they might forget him or overlook him through some clerical error. But they did come, he said, and his relief was infinite. I have been in jail some twenty-four days, now, and he was there more than two and a half years. If I am as relieved as I am, how relieved he must have been! And others will be.

Dinner over, I lie on my bed. There have been others here before me, and others will be here after me. No one ever mentions them. Time here is present only and a day in the future which is the day of release.

Tomorrow I will be home, "on the street," as they say. I will be reunited with Judith and our lives go on, and we may never be the same. You lie here and maybe you think that you will return to things as they were, but that you can never do, for you will never be the same.

It would have been nice if I'd been able to write each day during my jail term, and then I could really have a diary account of this moving adventure. But along with other things, that diary was denied.

What do I remember of that first night at Hart Island in Dormitory #10? That it was much more comfortable on the bed, though it was only the springs covered with the six layers of blanket and the hard pillow and the two coarse sheets, than I was the night before on the concrete floor. It took me a long time to fall asleep, and a long time before lights were turned on I was awake. I remember lying in bed those first nights looking mournfully out of the windows across the room, the sunset sky, occasionally a bird across the window, and the sea noises, fog whistles and bells, the first somewhat foggy night. I waxed sentimental, I remember, and wanted to cry but was unable and could not think of anything to cry about. I remember Dan O'Hagin in the berth next to me, also staring out of the window, and Kieran Dugan across the room, on his stomach, looking out, the divine skyline of Manhattan in the distance. One could see it only at night or in the dawn. When Kieran discovered it, I think it was on that first Sunday evening, I just about went wild with excitement. So did we all, craned and peered

and couldn't see enough of it, tried to identify the buildings, admired it, delivered verbal hymns to my city, our city. Flanked by the silhouettes of the George Washington Bridge and the Bronx Whitestone Bridge, it was for us an idol to worship.

That first night I had a nightmare in which an old schoolmate from Horace Mann passed through the dormitory at night while we were all sleeping. He was a traveling salesman who, caught in fierce storm, was permitted refuge in the prison for the night. As he walked through the dormitory he saw me and recoiled in consternation. Ned — Ned Weissman — a good bourgeois who had always been rather friendly with his Bohemian classmate — then seemed to arrange with the warden for me to return to my parents' home for a brief visit in order to explain to them what had happened. Suddenly, as in a dream, I was there, at their bourgeois apartment, in the night, amid their tears and ranting; shamed, I returned to the prison. I awoke, suddenly, and in a panic.

"How does it feel to be down to the bottom?" Biff asks. "Today is longer than the whole last month," I reply. "Yes. You do every second of it."

More and more I realize as I am closer to the life here that it is complex, and that the stratum one sees at first covers many others. On the verge of leaving, my last night in prison, I realize that though I have given it my close, close attention these twenty-five days, I but barely know it. Like anything else it has its infinite depths; for the men — and without them there is no prison — are infinite as any others. The effects that

prison produces on their behavior, these I know a little, but prison affects one infinitely—no, only, I'm sure, while one is here.

Faced by life, in any of its forms, I become painfully aware of my inability to comprehend it. So little simplifies and so much rolls onto the coral reef, indecipherable, unfathomable, inexplicable for me.

I cannot believe that I can return to a life of art now. I could never give myself wholly to it, and to succeed one must do just that, one must be obsessed. How can I give myself to art when I am tied to prison, to the warriors and their victims, to the tired, the poor, to the unhappy. To give an abstract painting may be enough. To give a beautiful play may be more than enough. Yet it is not enough for me. I need to give something else. Perhaps even something less, I don't know; but I do know that whatever I have given by being here in prison has made me feel better than all the works of art. Always unsure of the success of the art work, I am always sure of the value of the smallest act of love.

Personal and selfish, I receive more pleasure myself this way—I don't care or know anything about values—life is pleasanter and each moment, each meal, each step, each game and word more gratifying.

<u>Monday, Aug. 5, 5 a.m.</u> The cock crows. My own life and my own identity are no longer interesting to me.

Two weeks have passed since that last sentence was written. Now I am sitting in my studio at home, recollecting in tranquility those memorable days when I was so far from here—so far, indeed, that it might just as well have been the other end of the earth. But this is my room and my typewriter, there are innumerable possessions around me. In jail how I clung to the few personal items I had, especially the letters. Almost all the other objects were, alas, designed to be my enemies. Here everything around me is friendly, all of the objects are here because they are things to which I bear some loving attachment or some sensible responsibility. Nothing hostile, nothing calculatedly cruel or aggressive or offensive to the eyes. My friends are available and they are very dear, I have seen many since our release. All the good things and beautiful things of this world are apparent to me; yet I cannot help feeling that I have left one prison to enter another, a larger, gaudier, far more enticing and therefore more subtle prison. This wide world is a prison, but only because we have made it so. Do I say that men are guilty for building the prisons we know, the famous Alcatraz, Sing Sing, and every little jail, do I say that men are guilty for that, do I howl about the terrible sin of erecting such places, do I rail against the monstrous fact that these places even exist? Then what must I say when I say that this whole world is a worldwide prison, that we have imprisoned ourselves in a system in which we forbid ourselves to express our love? It is so vast, so complex, the bonds are so tightly wound, how, how shall we ever find release, how shall we ever transcend or destroy the bondage

we have set upon ourselves? And I am still sure that
with the grace and magic of great escape-artists, who,
mystifying even themselves, rise mysteriously through
layers of sealed sacks, ropes, locks and chains, upward
through rivers in which they have been tossed to drown,
we too shall rise, magically and in a magic instant, and
be free in the world to roam and to love. Each man
deserves all he desires.

While in the outside world it is increasingly clear
to me that the soul of man is suffering from terrible
cancers, the short time I spent in jail has convinced me
that in man himself, and not far below the surface, lie
all the balms and ointments necessary to cure our most
dire ills. This I wrote to Judith and to friends midway
in my stay in prison, and now, two weeks out, even
in retrospect, in my studio where I am not trying to
convince myself that jail is a pleasant place to be, even
now it seems to me just as true, and I feel it even more
strongly.

The problem is one of freedom. I entered prison
quite skeptical, quite tired, quite cynical about the
state of man. As a matter of fact, I was a bit bored with
the topic. What do my journals say? I've forgotten. I
think I had begun to accept a life in which I no longer
questioned or judged but simply did my own work and
what pleased me. I began to think this is all that a man
can do. When I entered jail, the full-fledged optimism
of my youth was dissipated. I made a gesture in the
name of peace because it was the only thing I could do.
I had long ago decided that I didn't, as a person, want
anything to do with the doom-eager madness of men

and the universal death-hunger. That kind of thing just wasn't my game. What are the islands to me if you are gone? What are the paintings and poems, the sunsets and all, if you are dead?

Alors, I sat in the park and defied the current madness. I kill enough each day in so many ways, I kill enough. I sat in the park utterly without faith. I did it because there was nothing else for me to do. To have obeyed the drill would have been an inconsistency that would have bruised my conscience much too much. We must love one another or die. I sat in the park for my own sake only. And only in those rotten prisons, among the dregs of society, was this feeling relieved. The men there behaved toward one another with more kindness and warmth and consideration, friendliness, yes, love, they showed me more love in those twenty-five days than I have gotten in two years from the majority of the people I have encountered. There everyone knows he is suffering and that everyone around him is suffering. There each man does what he can to alleviate the suffering around him, for what else should he do? Awareness is the light. I was transfigured. It was as if I had gone through a purging ritual and emerged with the classical keys of the mythical hero. In prison a man looks into the mirror and he sees his own face and it leads him towards glory. When he is released, alas, he puts on his mask again, the crazy mask that we wear that has no holes for the eyes to see through. In prison, unblind, you know that you are suffering. Outside we deceive ourselves with exquisite devices; and until we realize that we too are suffering, until the

worldwide pride relents and we admit that our world and ourselves are not a perfect picture of perfectest mind's creation, we cannot perform the simple act of compassionate love that will make us free, free to love and be loved.

Is it this way in other prisons? I do not know, and it does not matter. All that matters is that in an isolated circumstance I saw and felt this thing; I have the evidence.

Dai-enu. One comes to realize that anything is enough. Dai-enu. If the Almighty had taken us across the Red Sea and had not sent us manna, it would have been sufficient. Dai-enu.

<u>Workhouse Journal</u>, written in retrospect—on dry land, as it were, after the voyage.

The first night on Hart Island (Saturday, July 13), I dreamed that simple dream in which I felt painfully the shame my family must be feeling. I awoke before there was any sign of light and began to toss and turn, insomniac, until we were awakened. I greeted with distinct relief the turning on of the lights; it was more comfortable to get up than to toss in half-sleep. I did not sleep through the night once during the stay in jail; I have still not managed to do that, I who was so sound a sleeper. It is not that I am not tired. Certainly during the time that I was working in The Tombs I was tired enough; but my mind apparently was disturbed, restless. I awoke over and over again during the nights, and I still do.

<u>Sunday, July 14</u> We were awakened at 5 a.m. I smoked the butt of a cigarette I had saved. I still had two more cigarettes left. The dream had unsettled me. I was puzzling it, but other than that I felt quite well. There is always something of a rush for the bathroom in the morning, 135 men need four faucets and four toilets. Yet there was no rush to get anywhere, because it is long after everyone has laved that the dorm is called to mess. About an hour passes between the time we wake up and the time we line up in twos to be counted and then go out into the pale light of dawn and walk to the mess hall. Long line of men in gray clothing in gray dawn. In the movies you always see the men marching in military style. Nothing like that was tried on Hart Island. They had difficulty enough trying to make the men walk two by two, which was important for the counting. We ambled, straggled, slowly and loosely. The air, heavy with the sea, and clean, was a real pleasure. You need to be deprived of things every so often in order to appreciate the air, or the sheer beauty of a lawn, a hedge, or an exceptional elm. The water, too, surrounding us was something I was grateful for. Shimmering in the light, the soft light of dawn or the strong light of noon, it is always pleasure. We kept saying to one another that the prison looked more like the campus of a girl's college than what it really was. I really didn't feel that I was suffering very much, even though that breakfast that morning was notably horrid. I remember now the tin plates and bowls and cups as offensive.

But I also remember now the letters of Wilde and Dostoievski describing the prisons in which they were

confined, and for so long, so long; and then I find myself saying, well, actually, it's not bad at all, the view is pleasanter than the one I have at home from our windows; nothing is yet required of me; I eat and sleep; the bed is hard, but it is a bed: I did not expect it to be like the Savoy in London; all that I am suffering really is loss of volition—I can't go away—but I am with my friends and I love them very much, it is great comfort to be with them

We return from the mess hall, are counted again as we return to the dormitory. When the guard locks the gate behind you, you think you feel like animals in the zoo; you get a very clear picture of your last visit to the zoo when that happens.

Most of the men in the dormitory were tere for non-support, public drinking, vagrancy. A few were there for petty larceny or on charges of using or pushing dope. Seven for "Air Raid." Those first few days some of the hacks would cry out, "On the count! Air Raid!" or, "OK Air Raid! On the chow!" It was a not unpleasant jibe, and we all appreciated the recognition we were getting.

We spent all of that Sunday indoors, loafing.

After breakfast I smoked a cigarette and gave the last one to Sandy Darlington. I resolved to quit smoking. I might as well suffer something while I'm here. And so I said I was giving it up in honor of Bastille Day. I think Ammon was pleased when I told him that. Smoking would have been difficult anyway. I'd have had to grub, to walk around looking for butts, and to descend on newcomers who might still have

cigarettes left over from the time of their arrest. I'd have had to suck around to get some Bull Durham — the kind of cigarette you roll yourself.

I was anxious to write to Garry, to prepare him for our not arriving on visiting day, also to write my brother Franklin and to Lester so that they could take care of certain chores. I asked the hack about this, and he said I was permitted to write one letter a day to anyone I cared to write to, that I could get paper from the commissary as soon as I received a credit slip for the money I was arrested with. On Tuesday I would have to apply for commissary so that I could get it on Saturday, but if I didn't have my receipt by then, I would have to wait for two weeks to get the paper! Maybe I could borrow it from someone . . . I decided that if I didn't get paper and an envelope in time to write to Garry, I would try a hunger strike or something . . .

That day I read a bit. I managed to get ahold of a Bible and continued with the end of Genesis, which is where I was when I was at home. But most of the time I spent talking with my friends. I was beginning to feel like I belonged and wasn't so scared of the other inmates. I realized that they were not hostile. I began to talk to them. They were all unhappy to be in jail, they mentioned this, but that was all. The first question one is asked is, "How much time have you got?" The next question is, "What did you get busted for?"

If I had any anxieties those first days they were for Judith. Not knowing is one of the worst things about jail. You don't know anything but what you can see

and hear yourself. That is why the grapevine is such a big thing. You don't hear anything about the outside world. You are cut off. That is why you look forward to mail so frantically. That is why newspapers and news reports over the radio are so important. But there is no way of finding out things you want to know about your own family. You have to rely on the visits you are permitted once a week or once fortnightly or once a month, or on the letters. But so much is left out of the letters. How was she doing, was she upset, was she comfortable, was she taking it well, how is she bearing up, is she having as "good" a time as we, or was it bad there?

You worry more, in jail, about things on the outside that you cannot control than about conditions on the inside. Not knowing about yourself is another thing. What will happen to me? We were told nothing. We were not told what the program or schedule would be nor what we were expected to do, what was right and what was wrong. We kept wondering about where we would be sent, whether or not we would be separated, what work we would be asked to do. We lived completely in a state of incertitude. Rumors galore circulated. Everyone had a different story. You listened to these stores eagerly, but there was no way of knowing what the truth was. Old-timers had all kinds of idea. We were green, really, even Ammon and Dan and Mike, who had been there before.

When I go back again I'll know better.

I was afraid of the night and did not let myself nap

during the day so that I would sleep during the night.

This was the day that Kieran found out that the skyline of Manhattan could be seen from the east windows of our dormitory. The windows on the second floor had a clear view across the water. The skyline cannot be seen from most parts of the island.

Each night as I went to sleep, mournfulness crept over me. It must have been a kind of self-pity.

<u>Monday, July 15</u> This morning Ammon asked me to tell the others the story of *The Idiot King*.[9] They all stood around the bed and I told it, forgetting much, and to my surprise even mixing it up a bit; but in the main the forceful plot and strong ideas came through. Ammon had seen the play and had liked it very much. It was kind of fun, this interlude, when I told the story of *The Idiot King*. And I knew, too, that Claude would probably be very pleased when I would tell him this.

A day had passed and I had not smoked a cigarette. No one could have been more surprised than I myself was.

The weather was quite beautiful, the days were bright and clear and the sun strong. The island looked beautiful.

I found out that razors could be obtained by turning in your identification card to the hack. There were three razors in the dorm, and they were used for about fifteen shaves before the blade was changed. They had

9 Claude Fredericks's play *The Idiot King* had been presented by the Living Theatre in their loft theatre at 100th Street and Broadway in 1954 with Julian Beck in the title role.

47

a brush for lathering, regular hand soap was used, but since I have used hand soap for shaving for years anyway, this was no hardship for me. When you finish using the razor you return it and the hack gives you back the card.

The card was issued after the induction was over. As we were leaving that awful place we were given yellow cards with our names and a number. Mine was 483326. This became very important because from now on you are constantly asked your number and, strangely enough, your address. For instance, a guard comes in and you are wanted for something. He reads off a paper. "Beck." "Here." "What's your first name?" "Julian." "What's your number?" "483326." "Where do you live?" "789 West End Avenue." This little routine to certify one's identity went on almost daily for one reason or another. It was kind of nice to keep remembering that you had an address. Sometimes just the number was called out, but less often than I had imagined. I had thought that one's name was just about forgotten, that in prison you became a number only. Not so.

Life in a dormitory has many advantages; they are quite obvious, I think. But there is one serious disadvantage in that you have just about no privacy. Even in the toilet there is no privacy. Since I regard that kind of modesty as an unnecessary refinement, I didn't too much mind, not as much as some of the others. But it did take me some time to get over my inhibitions, not that I really ever completely did and ever did with ease go to the toilet—say it!—take a shit—while I was there;

but as time passed, it became easier and easier. At Boy Scout camp there wasn't much privacy either, and there they had latrines, not toilets, so this wasn't so bad, really, just something to mention and not to like.

This morning we went to the clinic for our medical examinations. We waited a long time to be examined, which was fine, for there was nothing else really that we would rather have done than sit there talking to one another and letting the time pass. The examination was very brief. "Iss dere anysing ze matter viss you?" "No, sir." "Very goot." The doktor then checked off a page of a questionnaire ("Have you ever had hernia, yellow fever, smallpox," etc.?). "You haven't hat any of zese tings, haf you?" he asked as he was checking them off. "No, sir." "Are you also a Tolstoyan vegetarian?" (Ammon had preceded me and had apparently said this to the doctor.) "Yes I am." "Ha ha, very goot, sank you. Next." Now I was officially fitted to do any work I might be asked to do.

The personalities of the guards. Or rather the personalities of the guards as they are seen by the prisoner. Fifty percent seemed nice; forty percent were just stupid and therefore unable to do anything but enforce the rules with a kind of stubborn rigidity, nice but stupid, and therefore sometimes senseless; ten percent I think were nasty, they acted as if it were incumbent upon them to sneer at the prisoner and talk to him in unpleasant tones, to enforce all laws sternly and to the letter, to insult as often as possible, and to take extra disciplinary action whenever the opportunity

permitted. This, it seemed to me, was no different than in any other walk of life. In any group of people fifty percent are nice, forty percent stupid, and ten percent nasty.

Now a month has passed, five weeks really, since we were released, and prison is at last getting out of my bones; I no longer feel a passionate need to write here, to record everything, I am no longer chained to it; I am looking toward other things, toward my other work. Now I want freedom. I want now to get away from this. But how can I not fulfill the promise of the notes I made for myself when I was in jail? How can I run off now and forget it all when I am forever there, forever on that island or behind those walls, behind the walls of all the prisons? So with exercise of discipline I perform what is now a task.

Monday afternoon we were given our first work assignment. It was a somewhat unsavory task. Myself, Michael Graine, Kieran Dugan, Sandy Darlington, and six others were chosen. Blackie, a youth who was there for dope addiction, was surly and hurt and angry and anxious not to work. His friend, a Spanish boy with sideburns, was quite gentle with large heart-breaking eyes set in a good-looking face. (The judge had said to him, "I'm sending you to jail because you're a punk, because of your sideburns and the clothes you wear, I'm sending you to jail to teach you a lesson.") Then there was Ferrera, whose name the guards consistently and comically mispronounced. He was a wonderful-looking man about 6'3" tall, Puerto Rican; he looked like a

Spanish anarchist, with dark, flashing eyes, a drooping mustache, and a lean frame that carried the weight of the world. We were chosen for what was called the Shit Gang. There is a project going on there on Hart Island in which human excrement is being converted into fertilizer. That is what we were told, anyway, and we found no evidence to disprove this. There were five concrete bins about 15 feet by 25 feet. The stuff is apparently drained and then dried in the sun. As one approaches one is impressed by the odor, but it is really not nearly so offensive as it sounds in the telling. It was unpleasant but it was strange, for the odor was really not so much one of decay any longer as it was the odor of something that could enrich the soil, and so it really smelled alive and therefore not awful. You get used to it and forget all about it in ten minutes, and then all it is is a matter of shoveling it into piles and then into a truck. It was hot, but I was delighted with the opportunity of being out in the summer sun for the first time this year, of being able to strip to the waist and to do some real physical work. Except for the work I do in the theatre, I really never do any, and so I might say that until I got into jail and began to do real work my poor body was on the verge of atrophy and that I profited from the work. We were not harried by the guard as we did this work. We worked in two shifts of five. Five worked and shoveled a load into the truck while the other five sat with the guard under a shade tree near the shore and watched the boats sail by. Athletes on water skis and thrill-seekers in seaplanes skirted about the island. None of them came near enough to wave to; the large

signs saying "Prison, Keep Off" probably did see to it that they kept their distance. We were anxious to wave because we wanted that bit of contact with the outside world. It would have meliorated the feeling of being cut off, of being locked up. There was a bit of a beach, and we longed to go in swimming. How much more, alas, one yearns for things that are forbidden! Unable to swim, we could only indulge in self-pity. All the time prison provokes the most loathsome and mawkish feelings inside the prisoner. It is an evil institution because of the ignoble emotions it fosters. It is in this way that it breaks men. Men that are filled with self-pity, with a sense of being denied and punished, of being less than men, of being afraid, these men are unfortunate. I remember being afraid not to work; the others seemed to feel this less than I; and I remember sweating profusely But that is part of my physical setup, I just do sweat a lot. The odor clung to us, to our skin and our clothes; when we returned to the dormitory, we could be smelled coming in. We washed ourselves and our shoes and it did help, but the stigma remained with us for a couple of days. In a way, I think, we all rather enjoyed it. Somehow we all had a weapon for the rest of our lives. When the right occasion came along, one could always say, "Ah, but I shoveled shit in the hot July sun . . ."

That night when we were in the showers (which were not in our own dormitory) we heard a news broadcast come over the air: "Today a young couple who refused to take part in the civil defense drill on Friday were sentenced to thirty days in jail. They are Mr. and Mrs. Richard Moses, who paraded in Times

Square carrying posters . . ." We wondered whether
or not Dick would be sent to join us, whether or not
we would see him. All these things took a place of
great importance. I began to worry very much about
Judith. I was sure she was probably more comfortable
than I, but I did fear that she might be separated from
Dorothy and that she might be very lonely. I was afraid
too that she might not like the food, and I wondered
what kind of work she might be doing. Then on the
other hand I assumed that she was a brave little girl
and probably with her friends, and that they are a
brave lot, and she is very likely doing even better than
I. But I wondered, and the uncertainty was very bad.

That night there was the first letter call. There was
no mail for me. Many nights were to follow in which
there would be no mail for me, and each night I would
be at least a little pained, and my loneliness would
swell each time my name was not called. Ammon did
get mail that night, a note from Pat Rusk saying that
Bob Steed had hit upon the idea of getting out a special
edition of the *Worker* and that they would picket the
Women's House of Detention "until you are released."
We misinterpreted this as possibly meaning that
the purpose of the special edition of the *Worker* and
the picketing was to try to obtain our release. We all
agreed that if it were so it would be quite unfortunate.
Ammon even was a bit angry at the thought. I must
say that the thought didn't really bother me, as I knew
there was no possibility anyway of being released, and
the idea of the picket line and all the fuss seemed to
me just dandy. Michael Graine got a note, too, from Pat

Rusk. This upset Kieran a good deal because he was, by far, a closer friend of Pat's, and she had chosen to write a casual acquaintance first. I sympathized with him, and we both spoke of how discouraged we felt when we got no mail. Now, how absurd it seems to feel a pang about not getting a letter, how small it seems; the values are not at all the same in prison—yet what did Wilde feel, who was allowed to receive four letters a year?

We socialized a good deal there in the dormitory. There was so much congeniality that I was reminded not a little of the feelings of friendship that I had at camp. It aroused a certain peculiar nostalgia. We were being treated like boys here, like naughty boys . . .

Going to sleep the same melancholy flooded me, and I fell asleep close to tears, not crying, for I realized that these tears which did not flow were not for myself. This choked-up feeling, this helpless empathy, was not for myself, it was for everything, as the gladiator in Paul's play[10] says, for everything.

The skyline of Manhattan was an emblem of glory.

Here there were comparatively few night noises. Everyone seemed to sleep fairly soundly, though there was a steady stream of men shuffling back and forth to the bathroom. I slept fitfully. I wondered if we would be sent to Hampton Farms[11] tomorrow; or perhaps I would be awakened in the middle of the night to be executed as in France; or, happily as in camp, to

10 Paul Goodman's play *Faustina* had been presented by the Living Theatre in 1952 at the Cherry Lane Theatre.
11 New York City reformatory in Orange County, New York.

be taken to the midnight induction ceremony of an honorary society.

Tuesday, July 16 This morning all those who had arrived on Saturday were brought to the office of the deputy warden to be interviewed before being assigned to a work detail. The office was in a pleasant cottage overlooking the shore. We waited on the porch for about and hour and a half before our names were called. Ammon was the first to be called. When asked what work he did, he replied that he was the editor of a paper. Perhaps the deputy warden was so surprised that he said nothing in reply. In any case, when I entered, he asked me not only what work I had done but continued, "What are you in here for?"

"Civil disobedience."

"What?"

"I refused to take shelter during the air raid drill."

"Oh —"

"Deliberately, sir. There were ten of us."

"What do you mean 'deliberately'?"

"We did it as a protest against preparing for war. We consider this air raid drill part of preparing the nation psychologically for war."

"What are you, pacifists or something?"

"Yes, we're all pacifists."

"Get your hands off the desk when you answer me!"

I was standing before him with the fore and middle fingers of each hand resting on his desk.

"I'm sorry, sir."

"Do you belong to some religious group?"

"Four of us belong to the Catholic Worker movement. I do not."

"How many of you are here?"

"Seven."

"OK. Wait outside."

As I went into the corridor, he could be heard asking his assistant, "Do you think they might start a demonstration here?" Those who followed were asked additional questions. If I remember rightly, Frank or Mike was asked whether or not we might cause trouble, were we likely to start a strike. I believe Dan was asked whether there was any work in prison which we might refuse to do. "Only if it weren't peaceful work," he replied.

At lunch, the clerk at the deputy warden's office (an inmate) got over to us and told us that we were gong to be transferred.

We did not go to work that afternoon but were returned to the dormitory. Ammon and Dan were separated from us shortly after lunch. They were told to get their belongings (blankets and sheets really). Ammon was sent to join the old men, the unfits, in the Sun Deck, a dormitory for skids, mostly, who are so incapacitated that they cannot work; also men with disabilities such as one leg missing, etc., are kept there. There are no bars on the windows, and they sit around all day on a kind of lawn in front of the dorm sunning themselves. What they do in winter I do not know. Ammon, of course, is still plenty vigorous at 64. I learned the ages of several of the men who classified as old skids. They looked much older than Ammon,

yet many gave their ages as low as forty-nine or fifty. I don't remember learning the age of anyone else over sixty. Somehow I felt that putting Ammon with these "old" men was an act calculated to humiliate him. Ammon in a jail without bars! Dan was sent to another dormitory. We saw them both later in the day (at supper mess). Dan told us he was in a dormitory with carpenters and plumbers, that he was to be used as a carpenter, and that there was a TV in the dorm. I was sorry to be parted from them. I respected each very much.

Dan, slim, tall, a gaunt look about him. Reddish hair and a roughly trimmed reddish beard. He himself tells the story of sitting in the subway and a little girl across the way looked at him and whispered to her mother, "Look, Mommy, Jesus!" The little girl was right, too. Sandy said that he looked like a prophet. His manner is extremely mild, he talks softly, with a rural accent. Before being arrested he had been working in Pennsylvania splitting rails for rail fences. Of us all he was the least sophisticated, the least familiar with art and literature. Yet one never doubted that he was wise. A fallen-away Catholic, as the Catholics call him, this Irishman is now a Quaker and the finest representative of their group I have had the pleasure of meeting. He made friends with other inmates with far more ease than any of the rest of us, so far as I was able to discern. He had no particular platform, no practical vision of a future free society. He always spoke of particulars: how to make a cabinet, how to make a table, how to cut grass. He spoke of love, of living, of his mother and his

aunt. He spoke of prayer, of his hope that our brothers in Russia would protest the armament in their country as we in ours. A world at peace in which men could do the good work of the world. He was very pleased when I gave up smoking and when I told him that I did not think I could do any useless work any longer. By being pleased, he was not reacting like an organizer welcoming a new member to his club, but simply as a friend who was glad that his friend would now surely be enjoying life a little more.

Ammon's manner too is mild, yet it is aggressive — an aggressive mildness. Ammon is the professional revolutionary. Ammon says that Dorothy says to him, "Ammon, you're too self-righteous, you're so right and so self-righteous that you make the rest of us all feel horrible. And you're so healthy and you talk so much about how healthy you are, you're so proud, Ammon, you're just going to get some terrible illness someday and it's going to kill you one two three!" "Well, she's right," he continues, "if self-righteousness comes from being right most of the time, well then I guess I am self-righteous, and I do tell people about it so I guess maybe that's being proud. And I am healthy. You see, if you eat no meat and stay away from starches and don't use any medicine the way I do, then you can stay pretty healthy." When there was a call for confession on the first Saturday night for those who wished to take communion the next day, Ammon did not go. "I have nothing to confess," he said, "I didn't commit any sin." (Kieran went to confession. I don't remember whether or not I told him what Ammon had said, but

he did say that he himself couldn't think of very much. He said he told the priest that he was thinking more of his own comfort than that of his fellow inmates, and that the priest had not been satisfied and asked him to repent a sin from the past.) Ammon is harsh, too, in his quiet way. He doesn't have many kind ways, for instance, with people who preach revolution but do not take any real action, who back down when the moment comes. He wants everyone to be dedicated like himself. Nor does he like sentimentality. "Giving money to drunks who panhandle you, why that's not doing any good, that's just weakness, sentimentality." Ammon found little to complain of. When he heard about the drunks or skids dying in the showers, he said that they probably would have died anyway. In prison he accepts everything, everything is all right. The food is good, the concrete floor is not so bad, the beds are fine, the hacks aren't bad, and if it is bad, well, after all we went to jail on purpose so we have no kick coming. If you don't like it, why that's just being an old lady, a sissy. Ammon was very proud of being in jail and wanted to "take his medicine" (a phrase I think he used and which I loathe). He was not the kind to do any ass-licking: he was not going to bill and coo to the hacks to curry favor or behave in an especially subservient way; but he was not, on the other hand, going to criticize the prison system; it was meant to punish — what do you expect? He is stubborn, he argues with a certitude that approaches adamance. He has practical outlooks and opinions yet no philosophical outlook, he has a stand, beliefs, a credo, a way of living but not a way

of life. Ammon is. He does. He is a man of action, not
of contemplation, he is not spiritual but actual. He
speaks a great deal about himself, and whenever he
gives advice about how to act he chooses an example
from his own life in order to illustrate the proper
behavior. He has little appreciation of art, I think, and
admires in literature only that which is demonstrative
of or sympathetic to his beliefs. He is outspoken and
occasionally disquieting and sometimes dull. Yet he
is altogether admirable. He is not a multiplicity of
things. He is one thing, that is all, he does not pretend
to be anything else; he is the revolutionary spirit.
He is a simple man who has chosen to speak for the
revolution, which of course leads him to jail—he has
been arrested twenty-six times. It must also be said of
him that he raised two daughters, sent them through
college through earnings made by working the land,
as a farm laborer in the West and Middle West. He
is honest, he is plain, he is good, he is a bore, he is
lovable, he is honorable, he is rare, very, very rare. For
all his faults, which are all small faults, he is a shining
example of a man, probably the most charming man
of principles I shall ever meet. It was a privilege to be
arrested with him.

They were transferred, but meanwhile we did
not know what would become of us. Sandy and I
shifted our bunks so that we were next to Kieran on
the other side of the room and could, at night, before
falling asleep, look out of the window at the water, the
twilight sky, and the faint silhouette of Manhattan.

Shortly before supper Dick Moses arrived. How

happy we were to be there to welcome him and show him around and tell him whatever we knew that might be in store for him. That night I found myself preaching about the Anarchist Revolution, the Free Society, the Moneyless Revolution. Perhaps I was suddenly able to preach because Ammon was no longer there and I felt that I had a new authority — I was now the oldest, and it was not unlike telling children, Mike and Sandy and especially Dick.

Wednesday, July 17 After breakfast of this warm day we returned to the dormitory to await X . . . The inmates sweep and mop their own dormitories. We were called to do this at least once each while we were there. Fine.

Our cards had been returned to us yesterday afternoon, and on the backs of them were written the names of the places where we were to be sent. On the back of my card and Kieran's it said CPM, standing for City Prison, Manhattan — The Tombs. Sandy was to be sent back to Bronx County Prison and Michael to Queens. I am not sure of the time our names were called. That was another thing on that island. It was timeless. There were no clocks. This disturbed me very much. I'm sure that most of the prisoners were not particularly bothered by this, but I always like to know what time it is. I look at my watch about every half-hour, I guess. As a matter of fact, I am very good at telling the time when I don't have a watch, I usually guess within a matter of minutes. But there on the Isle of the Dead I was always wondering what time it was and was never quite able to get a look at the watch on

the wrist of a passing hack in order to be sure of what time it was. We were told to get our stuff. The officer in charge seemed to behave as if we all knew where we were being sent. "Who's going to Manhattan? Come over here." A group of us stepped forward. How we knew that we were being sent there I do not know. That is, I don't know how we were supposed to know that we knew. Presumably the letters CPM would mean nothing to us. They were scribbled, a kind of notation for the authorities but not for us. Yet it was assumed that somehow or other an inmate would know what was happening to him. The "system" would keep him informed. Everything was like that.

We brought our linen back to the laundry house and then were sent back to the induction center. There were six of us being sent to the Manhattan prison. We were handcuffed in pairs, Kieran and I to one another. I remember a man by the name of Goodman who was being sent with us and another named Isaac Jones. Goodman is a chemist about my age, who was in for four months for non-support. He was well off, but his wife was living with another man, and he felt that they were extorting money from him so he put his affairs in order and decided to sweat it out. I guess in this way he would do them out of their money and win something. I really don't know. He was kind of smart-alecky, but likable. He was a little too anxious to beat the jailors' system to interest me. But he rode with us. Alas, I have forgotten the two others. Again we were put into the rear part of the van and sent across the water. Because of the heat, the guard left the door

open until we got to the other side. It was stifling The entire trip took three hours. There were stops made at the Bronx County Courthouse and the Arrest Court on 165th Street where we had been tried. Because we asked to be fed, they stopped at the Bronx Courthouse and we were each given a bologna sandwich. I gave my bologna away. It got terribly hot in there. The windows are so tiny and so dirty and there is a mesh so thick around them that it is impossible to see out, really; yet we strained, all being anxious to find out where we were and where we were going. I amused myself thinking that I might spot a friend passing on the street. None did. We griped a great deal about the heat inside the box, about being crowded, about the small lunch, about the bumpy ride on the steel bench and about not being able to see out and being handcuffed and locked in as we went racing across bridges (water again).

That is one of the great sorrows of prison. The prisoner begins to feel sorry for himself. He exaggerates every inconvenience into an enormous discomfort. This almost becomes a game. It is manly to comment — not complain — on the nastiness of the situation. But one begins, inwardly, to develop an ugly kind of self-pity. A dreadful thing for the human being to cultivate, one begins to feel weaker and more pathetic until you begin to believe that you are pitiable and weak. And how to get free from this. When I am released will I no longer pity myself? Or will I always pity myself because I was in jail? This is awful. You feel so hard that you are suffering, you feel so beaten, so unfortunate, so mistreated. And you are made

to feel that you are wretched. Indeed you are made to feel that you are lower than the ordinary human being; so perhaps there is some sense to the self-pity. But you can defy the fact that they are trying to make you feel inferior, that you can defy, so it is all right, but you cannot defy the self-pity. That is there and is, I am afraid, ineradicable. Therefore going to prison reduces a man's strength. But, as Emerson would point out, everything has its compensation, and prison gives one a strength, too; it is the strength that comes out of suffering. Because as Gertrude Stein has so magnificently pointed out in a paragraph in *Three Lives*, when you really come to suffer, you find that it really isn't as terrible as you thought it would be, since you are suffering and you are able to bear it. Prison gives you a knowledge of your own power, but everything has its compensations — it weakens you too. Self-pity.

We got to The Tombs and rejoiced at being let out of the van, The hacks who received us at The Tombs were pleasant and cordial. The handcuffs had been removed after we were inside the building. Our personal property was once again checked; we signed again for the property bags containing our valuables that had been sent down with us from Hart Island. We were fingerprinted again and asked what work we had done on the outside. I hoped that I might be sent to work in the hospital. This sounded to me like "noble" work. There were again the usual rumors about what work was like and what assignments were likely. Sitting there in my gray uniform I felt very superior, very much the old-timer, the hardened criminal, as I

surveyed the newcomers as they arrived and were put into the bullpen. I tried to keep track of my sense of direction so that I could figure out exactly my location. We were taken to the third floor. We got out of the elevator, the hack who was escorting us cried out, "On the gate," and another hack arrived to open the heavy barred gate to the floor. Then another barred gateway, whose bars surrounded heavy glass, was opened, and we were inside a large dormitory. There was a television blasting away. The room, which must have contained about a hundred beds, was completely sealed in . . . "Here we are completely sealed in . . ." The guards sat or stood in a room outside and could look in at us; we could look at them too, for cats can look at kings. Occasionally I would notice one of the hacks craning his neck and looking at the TV set through the glass. It was quite funny. But then, of course, he did have his own TV at home.

"On the count!" I already mentioned this business, this constant counting and recounting of the prisoners—incessant, and they never seem to get the right figure, there is always some error. Here in this ultramodern dorm the mirrors were made of polished metal and secured to the wall. They looked liked the mirrors in the funhouse at amusement parks that deliberately deform the face. There was a little wall about three and a half feet high between each set of beds (an upper and lower). And there was a tiny foot locker for each pair of inmates. There was a little wall between the toilets. This gesture of respect for privacy I found very moving. The place seemed well designed.

The beds consisted again of simply a flat spring over which you could spread the three blankets you were given as a mattress. The springs here at The Tombs were of such a nature that they could not be plucked apart. At Hart Island they could be plucked apart, and one might have molded a lethal weapon out of one. The place gave me the creeps.

We were called for supper and sent downstairs to the second floor, where we ate in a spotless stainless steel and tile mess hall. The chairs here, as at Hart Island, were pinned down so that they could swivel but could not be moved or used as a weapon. I began to realize that the designers of these places had to knock themselves out thinking of ways to prevent convicts from attaining to any mischief. The Tombs is not a maximum-security prison, but it is a pretty good one. The food, I noticed, was a little worse than the food on Hart Island.

We returned to the third floor, and lo and behold, there were Mike and Sandy. What a dandy reunion, we were all delighted to see one another. Evidently there had been some kind of mix-up, no one knew what it was, but here they were. Whether they would be here long we did not know. They might be transferred out the next day. In any case we were glad to see one another. They went to supper.

I began to consider my state. Something very strange had happened to me. I was not myself. This was clear to me, but at the moment I was not certain what it was. Feel it, I told myself. If you feel what it is then you have a chance of knowing what it is. Then I realized that

there was nothing to feel. I was feeling nothing. I was feeling nothing. I had no sensation. Then I came to the verge of crying with terror: I have been robbed, I have no feelings, give me back my feelings!

Well, the fact that I could want to yell, that at least was something. I was behaving like a boy at camp, though I was not having a good time. I was no longer me, I was an abstraction being punished. In order to survive I had to have no feelings. It all fitted together suddenly. That was why for the first time in more than fifteen years I had awakened in the morning without an erection. This had happened five days in a row. They had taken away my masculinity and my sex. I had become a kind of eunuch. Neither the idea of a woman nor a man was interesting to me. They had done a complete job.

No doubt it came from fear, from uncertainty, and from the need not to feel. How would I ever get it back? How would I ever regain my own dignity? I spoke to Sandy, Mike, and Kieran about this. They agreed with me about the feeling of helplessness, of being less than a man.

The noise of the television machine was deafening. The sound has never been properly adjusted on those machines. I don't know what it is technically, but there is a disproportion in the amount there is to see and the amount of noise the thing makes. People seem to turn them up loud in order to block out all sounds of the real world. Sandy and I put toilet paper in our ears in order to escape the noise a little.

It was here that I decided to keep some notes and

as much of a journal as I could. If they took it away from me when I left, then that would be my hard luck. I would risk it. Since I still had no paper and no money to buy it with, I tore out the fly leaves of a book. This is done all the time in jail. Inmates tear out the endpapers of books in order to have something to write on — usually scores for card games. In a tiny hand I began to keep my notes. I did this because I thought that I might be able to slip these notes in between the pages of other papers when I was being searched when leaving and that this might just succeed. This was excellent foresight, because it did. Were I imprisoned for a longer time, I would apply to the warden for permission to keep a journal. I am sure he would grant it, also permission to do creative writing.

There was a glass door in the dormitory leading to a small room which was the prison library. It contained about a thousand books all neatly arranged. The door was locked. I asked several other inmates when the library was open, and none of them seemed to have ever heard of its ever being opened. Mike and Sandy said — two weeks later — that they had succeeded in getting it opened by insistently asking about it. There was as usual a good stack of books in the dormitory. Again, no Bible. If you want to read in jail, there is plenty of time and plenty of books available. I also noticed a sign which informed you that you could have books sent in from the outside by applying to the warden; if permission were granted, they could be ordered from the publisher and mailed to you by the publisher (and paid for by some friend or relative

on the outside). I was told also that you could have publications such as *The New York Times* or *Time Magazine* mailed to you by the publisher.

I went to sleep that night reflecting still on my loss of manhood.

Thursday, July 18 We woke at 5 a.m. I know because there are clocks here. That was one of the things that delighted me when we came here. At last I can tell what time it is. After breakfast I was assigned to mopping the dormitory. Michael and Sandy were called out and left; they did not take their "belongings" with them At about 8 o'clock Kieran and I were called, with a few others; we were asked to get our belongings. A guard took us through the various gates and to the elevator and up to the eleventh floor, where there was a dormitory sixteen feet wide and about fifty feet long. There was a row of eighteen double-decker beds on one side and the same on the facing side, with an aisle between them. There were five cells with open doors at the far end, each sleeping one man. I was put in the first bed, the upper. This had its advantages and disadvantages. We put down our bedding and towel and were taken back to the elevator. I was sent to the sixth floor.

Madness. It looked more like a prison than anything I had ever even seen in the movies. I reeled. First there was the sound of a great drum of voices, a hum that had grown into a drum. Then the gates and all those bars, endless barrages of bars. Cell blocks, one on top of the other, tiers of cells, the doors of which were opened and closed by a switch in a locked box controlled by

69

the guards. Security tight, frozen, locked; little cells containing men caged like proverbial beasts, their voices swarming. A hack asked me my name, told me I was to work in the kitchen, but "This morning we're short on help so take a mop and mop Corridor A." I took the mop. Another prisoner told me to follow him. I did, to the end of the corridor, where it turned. There he grabbed me, pawed me, and did all that he could in the space of a few minutes to seduce me. I broke out into a cold sweat. There were men watching, but none of them seemed to mind. There were men who were on the lookout for the hack. I insistently declined and, trembling, escaped. All this happened within five minutes.

How can I describe that place? It seems too complex. Such a complex series of bars and gates. Essentially the floor consisted of two floors of cell blocks, one on top of the other. The cells were in the center of the floor, so that no side of them bordered on the wall of the building, so there was no means of chopping a hole to the outside. Maybe a diagram will help.

Each floor keeps a different type of criminal. The fourth floor houses the petty offenders, misdemeanors, etc., or a light or trivial nature; the fifth, traffic offenders; sixth, felonies; seventh, manslaughter; eighth, sex offenders, mostly homosexuals; ninth, dope addicts awaiting trial; tenth, dope addicts going through the cure (there are also some in the hospital on the twelfth floor). So there on the sixth floor I suddenly found myself surrounded by a bunch of men who very likely had committed a crime of a serious nature — grand larceny, forgery, armed robbery or attack, felonious assault (which, however, frequently meant barroom brawling).

As I mopped along the corridor, the men in the cells talked to me. Since they are being kept there for trial, and since they are considered innocent until proven guilty, they are not required to do any work. I gathered that I was part of a crew whose function was to service these men. It was like a grand hotel. We were in uniforms, and they were in civilian clothes. Peculiarly, they did not behave toward us as if we were equals, but more as if we were their servants. This perplexed me and still does to a degree. I think it is that they have not yet been sentenced — even though they are being held by the law as prisoners — and consequently since they are not yet convicts, they belong to the higher classes of the caste system which is given recognition by the very existence of the convict in a prison. Since they are not yet convicts, they need not yet share the convict's suffering. They are not yet a part of his community; they have not yet sunk to his level.

All day long I received proposals from various

prisoners, both detention men and the convicts. The day — the whole day — overwhelmed me. The work was strenuous and often under pressure, the place itself I found extraordinary and grim and terrifying, the nervousness that is connected with the job I had to do — I will explain this — and the homosexual frantic madness, all combined to exhaust me; by nighttime I was really ill from it all.

When we returned to the dormitory, I talked with Kieran, and that was something of a comfort. I decided to let my beard grow as a kind of protection against my admirers.

<u>Friday, July 19</u> Waking up in this dormitory is very different. Lights are turned out here at 10 p.m. They wake you up at 5 a.m. So you only have seven hours sleep, and you are working a work day that lasts thirteen to fourteen hours. So naturally you're tired. A bunch of tired men drag themselves to the washroom and try to get ready in time. Somehow very soon after getting up the hack comes in and begins calling floors, "Fourth, fifth, and eighth." If you work on one of those floors, he unlocks the door of the dormitory, and then the main gate of the floor, and you go down to work.

Riding the elevator down in the morning makes sense, but taking the elevator up at night when you have finished work always surprised me, somehow, and made me feel that I was in a strange place. When you leave the building in which you work when the day is over, you take the elevator down, not up. That's logic. But of course prisons are illogical.

A little before six o'clock we were called to our floors. Must have been about a quarter to six. Hated getting up to the sound of a whistle.

When we get to the floor, we set up for breakfast. There are five of us. Then the two wagons of food are sent up from the kitchen, and we mete it out onto the metal trays made for the purposes. These trays are stamped into compartments. There are no plates. It's quite disgusting. There are cups, bowls for cereal and soup, and the round soup spoons with which everything is eaten.

Before and after each meal the spoons are counted. This is a bore. Rarely does the count after the meal tally with the count beforehand. Finding lost spoons is a pain in the neck, and the truth is that they really don't bother too much about it. When the count is wrong, they let it go.

Then the food is carried to the prisoners' cells. An officer goes with you to make sure that every prisoner gets a tray and also that he gets one tray only. As soon as you have finished serving the breakfast (somewhere between 7 and 7:30), you can eat. You are not supposed to eat until all the prisoners are served. The purpose of this is to be sure that the food lasts, that you do not run short. The officer in charge is responsible, and I suppose it does not reflect well on him if you do run short, it must mean mismanagement or something. In any case, you are not supposed to eat until all the serving is done. If you are seen eating, the hack can refuse you the right to eat that meal. However, this rule is not paid any attention too much, and you do sip

some of the coffee or juice, etc.

Then after breakfast I and another inmate wash all the trays and dishes while the other three collect the dishes and sweep the corridors and mop them. The kitchen is quite small. All the dishes are first washed by hand and then put into the automatic dishwasher. It became extremely hot in the kitchen. I used to take off my shirt, and the sweat streamed down my back and brow. The water was so hot and the tin dishes so hot that by the end of my stay there in The Tombs, the tips of my fingers were calloused. As a matter of fact, one of the hacks who had spoken to me about why I was in there was quite upset when he saw me working in the kitchen — that must have hurt his conscience — and he said to me, "Gee, you shouldn't work so hard, not you." As if there were something wrong with work. Alas, we have gotten to believe that the only way to live is to hardly work at all. We have lost all respect for labor, it is something degrading. What we do hold dear, I do not know, but I am sure that it does not surpass in value good hard work.

The rest of the morning was usually spent helping with the mopping and servicing the cells — distributing soap or toilet paper, etc. Then there was usually about an hour free before the lunchtime stint which followed. During the free hour in the morning the men shaved.

In the afternoon on weekdays we were required to do extra work — wash bars or cabinets or toilets or walls. At 3 o'clock we were free for an hour until 4, when the supper stint began. When the supper stint was over, all the meals served, the dishes washed and

the floors swept and mopped, the spoons counted
and returned to the kitchen (that is, taken out of our
department and sent downstairs), we were free to go
back to our dormitory. I say "free," but what I really
mean is "ready." This was usually about 7 o'clock.
Sometimes, if there was any problem such as no hot
water or a shortage in food, requiring that we wait for
extra to be sent up, it was as late as 8 o'clock.

That was the day. This day was repeated seven days
a week. On Saturdays and Sundays there was no "extra
work" in the afternoons so there was an extra hour
to loaf around, nap, read, write letters, or play cards.
This long day goes on around the calendar. There are
prisoners in The Tombs serving sentences of from one
to three years who work 365 days a year this long, long
day.

The men held in the detention cells were let out
in the morning and in the afternoons. For two hours
they were allowed to be in the corridors outside their
cells. During this period they played cards with one
another, conversed, and paced. Many of them paced up
and down the length of the corridor at a fairly fast clip
in order to get some exercise. They too were allowed
on the roof only once per week. The cells in which
they were confined were five feet wide and seven feet
deep. They contained two beds, a desk, a toilet, a sink,
and two towel racks. They were designed to hold one
person, but the overcrowded condition had resulted
in an extra bed being welded into the room. It was
a monstrous sight to see these men locked in these
horrid little rooms. When I go to the zoo it always gives

me a painful twinge to see the animals there locked
up in those ugly cement and steel cages away from
their natural environment. While I was in this prison I
wished I were blind. I hated to see what I had to see.

At dinner time, extra men were sent up from the third
floor to help distribute the dinner trays to the cells. One
of the men told me that my buddies Frank and Mike
were still there and had been assigned to work in the
House of D (the Women's House of Detention).
 The maintenance man arrived. Something like a
handyman, he goes around with a hacksaw all the time
and fixes things here and there. Electrical, plumbing,
and carpentry problems are brought to his attention,
and he works on them under the supervision of
the hack he goes around with. He goes all over the
building. As a result he is one of the most important
features of the Grapevine. The Grapevine is the method
by which news travels through the prisons, and it
is very active indeed. One day while riding in the
elevator I met someone from another floor who gave
me a message for someone on my floor about writing
to his wife. This goes on all the time. This is another
one of the means of "beating the system."
 The television set in the dormitory where we slept
blasted away from the time we were brought back
to the dorm till the time we went to sleep. The thing
was always on much too loud. This is a phenomenon
that plagues life on the outside too. Apparently there
really is something wrong with the soundbox structure
of the machine. It has to be played too loud in order

to be heard. I really don't understand, but I know that this is so, that all of modern life is constantly under fire from the audio munition of these infernal machines. There is no peace in family life, wherever you go these machines can be heard blasting away like the prophets of destruction. In the dormitory it was almost intolerable. I am told that Anna Kross, the new commissioner of the Department of Correction, is responsible for the installation of these machines in recent years. She is to be congratulated; indeed most of the inmates are extremely grateful and feel that she is doing much to improve the prisoners' lot; and there is no question that the television machines are a solace for the exclusion from the outer world which one suffers. How can one not be grateful for this boon? Yet there is something so fiendish, so much a part of the devil about these machines, that you wonder whether or not they are really a boon or whether they might not be a soporific that helps the time to pass more easily but which simultaneously is destroying the backbone of the watchers. Perhaps the deadliness of silence, the ennui of no television, and the card games that would replace it would be better. Each night for two or three hours my aural sense had to submit to this frightful barrage. It was almost impossible to read if one wanted to. Actually I was tired at that time of day, and most of the time was consumed by showering, washing out socks and shirt, talking to Kieran and to the other men. Often I wrote letters in the evening or the journal which constitutes the beginning of this record.

The homosexual pursuit did not cease. At night

I was approached during my sleep. I awoke to find
someone in bed with me on several occasions, or asking
me—poking me till I was awake and asking me—or,
on one occasion, a group of men, four to be exact,
got together and decided to force the situation. They
expected to succeed by holding me down but were
discouraged by the first gesture of resistance. I was
threatened with physical harm, rebuked, reproached,
accused of being anti-negro. "Is it because you don't
like colored?" The whole business I found terribly
exhausting. No doubt a great deal of my problem arose
from the fact that I was tempted to participate but had
consciously declared my intention to resist. I was, for
one, extremely afraid of the unpleasant consequences
of being caught, as that would reflect upon the "cause"
with which my being jailed was connected. It would
be a kind of sabotage to risk "defaming" the name
of pacifism by involving it with the kind of thing so
frowned upon by the world in general. Then there
was the matter of risking the five days good behavior
time. To lose that seemed a terrible thing. (Is it not
astonishing that five days can seem so valuable? How
blithely we kiss goodbye to five days in this outside
world. In jail it seems a substantial part of one's life.
Perhaps this is not the case in a jail where the sentences
are long.) I resisted. It became quite clear to me that
I was not refusing but resisting. There is a difference.
You can refuse because you don't want to. But to resist
is something else. I realized that sexual intercourse
represented a kind of salvation. Under the pressure and
influence of the importuning, sexual feeling returned.

I again was capable of an erection. I could feel myself responding to something. There was a definite need for some body warmth, for some affection, for a sign of being desired and of desiring. It was this, I realized, that homosexuality served the function of in jail. It was not only a release for feeling, it was the very means of feeling something. Naturally its practice is prevalent. Added to that is the simple fact that in prison one of the chiefest occupations is that of getting something which is prohibited. To get some extra sugar or salt, both of which are at premiums, to get civilian underclothes, or some nutmeg (on which you can get extraordinarily high), to get some good food from the KK (the Keepers' Kitchen)—fresh fruit or good meat— to get some free cigarettes or candy bars, this is the big thing—and of course the biggest thing is to get some sex; for of all things that are the most prohibited, that is the thing from whose lack the prisoner suffers most. He talks about it all the time, about the fact that the worst thing about being in jail is that you are deprived of the normal outlets for having intercourse. The majority of the men in jail who indulge in homosexual interplay are not homosexual by nature, that is, they do not practice it on the outside. I doubt that very much. But in jail it becomes part of the mores, just like earning a living on the outside; and also it becomes a need, not only the simple sexual need, but it becomes a need because if you do not indulge in it, you may end up feeling nothing at all, you may really be disfigured by jail, you might become a eunuch. There is nothing more natural in prison than homosexual intercourse.

At first one is horrified by the homosexuality. It is terrifying. To anyone begin pursued it looks like another assault upon one's body, another violation of one's privacy which one can only turn from in horror. When I read about homosexuality in prison when I was outside I looked upon it, too, with real repugnance. It seemed too crude to have any love in it, it seemed perverse — and I am fully familiar with active homosexuality — but in prison it seemed somehow even more callous and slimy than any conceivable intercourse on the outside. The fact that it was being brought about by the lack of any other sexual situation made it seem all the more unbearable — prisoners must indulge in this because there is no choice, it is like having to eat the inedible prison food. So it seemed. On the outside the official position was far more disturbed about this than I ever would be. I might be somewhat perturbed at the fact that homosexual intercourse would be forced on men who did not want it; but the official position and the reaction of the average citizen would be that this was an evil that a criminal of course would exploit, and this is an evil which must be burned out. With all the prison reform that has come about during the last half-century the jailors have become aware of the homosexuality as they were not aware of it in the past. And while they have gone about uprooting as much prison treatment-evil as possible, making the life in the prison more bearable for the inmate, they have simultaneously tried to blot out the homosexual intercourse — rather I should say the sexual intercourse — and thus they are taking out of the prison

system one of the few things that really rehabilitated the prisoner—for it made it possible for him to express his feelings rather than repress them, to feel something, some kind of affection for his fellow man rather than drive it out and develop hostilities in its place. But this will be a hard lesson for the outside world to learn. Indeed even I, a remarkable fellow, was slow in learning this. I, who am devoid of puritanical ideas but not of puritanical responses born out of conditioning, I was capable, at first, of reacting with disgust at the idea, and with panic at the reality.

I still had not received a credit slip for the money I had been arrested with, and therefore I was unable to purchase anything at the commissary. There was really nothing I wanted with real desperation. I knew that on Monday I had to get a letter off to Garry, but I would be able to get paper and a stamp and an envelope for that from another inmate. I enjoyed the candy bars—they were given to me as favors for wooing and I simply could not refuse them, for after refusing two or three times it became a hostile act—but I didn't want them badly. I would, I suppose, have brought a toothbrush and toothpaste if I were someone else and not Julian Beck. But of course I did react with a certain irritation— it was something to beef about—about the red tape being so severe that I didn't even have my money yet.
Since one is deprived of so many things, and since so little really happens in jail, everything becomes magnified and takes on an importance that could never be attached to such in the outside world. You are aware

of everything. Everything is important, everything
is interesting. Outside, this is impossible; there is too
much, not too little.

Friday night Kieran received mail. He read me
the letters and I listened eagerly, though I felt deeply
distressed that no one had written me. I felt forgotten,
neglected, a pathetic figure. But it was through
such feelings that I was able to feel my way to the
knowledge that to perform such an act as we had
performed for the purpose of gaining sympathy or
publicity or even notoriety was a vast mistake. On
that level the act must fail. Only if the act is performed
because there is nothing else that you yourself can do,
only if you do it for yourself because you cannot live
with yourself if you do anything else, only then is the
act capable of being successful. If there are any other
reasons, the path is open to failure, to disappointment
and resentment. It must be an act in which you give
your entire self, expecting no compensation.

Saturday, July 20 The entire place is sand-colored.
For some reason that has been selected as the official
color. Not gray, not green — those two colors being so
frequently the official colors of institutions. The sand-
colored walls and the lack of light make the place
very much a tomb, and I like to imagine that Cheops
reincarnate may momently appear. I look up and expect
to see him floating down a corridor. (What corridor?)

This is the night we went to the roof and I capsized
into ecstasy.

At night before falling asleep I watch a ballet of

mice. This place is kept almost painfully clean. In order to keep the inmates occupied, much time is spent sweeping and mopping and sweeping and mopping. Yet the number of vermin in this all-steel all-cement building is astonishing. At night they seem to come out of the trash can that stands at the entrance to the bathroom. There is a bright light in the bathroom which illumines most of the dormitory. They come out and perform a little ballet right here for me. They are quite adorable as they go about finding bits of candy, I suppose. They look like the very paragons of mice, big ears and long tails. And they are free to go if they choose. Suddenly they scamper away, and I know that the guard is coming.

The hack comes into the dormitory every twenty minutes, if I figure rightly. He walks to the end of the room, and there he punches a time clock and returns. Each time, he has to unlock the door and then lock it behind him. This is a very unpleasant thing, this constant locking of that door, all night long. Also it is unpleasant this sleeping with the lights burning all the time. Some prisoners put towels over their eyes as shields. I don't really mind, but it would be nice to be in the privacy of the dark. The lack of privacy, as I have said, is both a benefit and an annoyance. One yearns to be alone, though the alternative — being alone in a cell — is not at all alluring.

I forgot to mention the Hebrew Services. But they must be described. Friday afternoon at about 2 p.m. there was a call, "On the Hebrew Services." On the eleventh floor is an auditorium. It must seat about 300.

The seats are like pews. There is a platform and an Ark. As I look closely I notice that the Ark can be swiveled so that it will reveal when it is turned 120° a Catholic altar, and when it is moved again, an altar befitting Protestant services—a tripartite affair, very clever. Above the Ark it says in English: "Here O Israel, the lord our god the lord is one." There were eleven men at the services. I was the only convict; the others were all detention men. When I came in (escorted by a hack) the other ten were already there. The rabbi gave me a prayer book and cap (which he kept inside the Ark). There was no scroll in the Ark. He was conducting a reformed service in English, following a text distributed in pamphlet form by Temple Emanuel. It was immediately apparent that the rabbi was nervous. He was trying to get through the services as quickly as possible and evidently labored under the illusion that his congregation was bored by this part of his program. When the brief service was over he said, "Well, boys, as you know one quarter of the hour is for the services and one quarter for Jewish news and one quarter for Jewish music and one quarter for reading from our Jewish literature." There was no sermon. He read little stories from the Talmud illustrating the fact that it is bad to steal. One could feel the discomfort of the rabbi, that he felt the "boys" were not to be trusted, that only the goyish guard who sat in the back of the auditorium made his life secure; were he not there, the inmates might tear him limb from limb. His condescension was appalling. Instead of bringing us the word of God, he brought us speedy services, stories whose morals

we all long since understood, he played cheap Israeli songs pretentiously sung by Jan Peerce or Richard Tucker, and he read us a lot of chauvinistic news about the Jews of Israel and about the great good deeds and accomplishments of Jews such as Bernard Baruch or Albert Einstein ("New School Opened Named After Einstein"). Instead of bringing love he brought fear and the scorn inherent in his pathetic condescension. And it was hard to love him, hard for me to love him, because he was himself so altogether lost and pathetic. I could much more easily love the convicts who did not pretend to virtue. It was with great relief that I was able to love. I returned next week to break the monotony of a long week, not because I was returning to something, but because I was getting away from something.

An atheist excuses nothing in religious form and action; an atheist excuses everything in religious form and action. This is not a paradox. Since, on one level, everything is acceptable to me, I can both excuse and not excuse. I may not like it, or rather, I may not prefer this or that, but realizing that it is things as they are, I accept this or that; for I accept everything. Whatever is, is correct. There is no right and wrong; and there is a right and wrong. This is not a paradox. A paradox implies a contradiction. There are contradictions only on one-level existence. On one level, therefore, I despise this simpleton of a rabbi, and on another I find him sweet and sad, sick only from ignorance. On another level I find him radiant like the Star of David. He is all these.

Tonight there was a letter for me from Judith. Also

a letter from Rose Anderson. The letters were given to me when we came down from the roof. I was in a state of real joy. The light of the sky had been so beautiful an experience, and then the letter from Judith such a marvel, such a thing of love and pleasure that I really could not measure my joy. She writes, "It is really such a fine thing that is happening to us that any moments of despair or loneliness are a thousandfold repaid in the long view. My only worry is your welfare." But of course, what a perfect mirror of my own thoughts. Merely to be so far from someone and to be so exquisitely in tune with them is a sensation of pleasure. And she is sharing a cell with Dorothy and writes that it is a delight and a privilege. O but of course, my own dear one is really close to me, what she writes is what I hoped she would write, she is near to me, near to me, and she writes so beautifully, so expressively and so wisely. How fortunate I am in having so great and brave a woman! What a privilege that is! She has gotten permission from the warden for us to correspond with one another, though usually inmates of different institutions may not correspond. I begin a letter to her right away. No, I must get permission just as she has. How do I go about that? I must write to Social Service on Riker's Island. Then they will reply. Perhaps I shall never get permission and she will wonder what has happened to me. This evening the maintenance man said that he could get a message for me through to her at the House of D. I scribbled something on a piece of paper. Perhaps she will get it and she will think I have lost my mind or am in solitary. This is awful. The

letter from Hope Anderson is simple, written in haste, but certainly a comfort. Someone on the outside has thought of me, and even admires what I have done. This too filled me with great pleasure, and I was able to go to sleep that night less troubled than I had been since I was "admitted."

Sunday, July 21 It is Sunday but the routine continues as every day. Seven days a week, all around the clock. Sometimes I don't believe that this is happening to me. Sometimes I don't believe that this is happening at all. I look around me at the absurd and horrible picture I must see, and I simply cannot believe in a very basic humanitarian outpour of feeling that men have done this to one another, that they have done this to themselves. For there is no difference between the imprisoned and the imprisoner. We are all responsible.

The seducers continue their advances day long, night long. I am less bothered by them now internally, the problem is how to keep saying no and not arouse animosity. I have been threatened again and again and am slightly in fear of being forced to submit. But these men I am sure are not as desperate as they might be if they were here on really long-term sentences. And then again, if I were here on a long-term sentence, there is no doubt but that I would behave differently. I am told — from those who know — that if I were in a prison upstate, such as Attica or Sing Sing, I would have no choice, except the choice of my mate.

I put aside all little ideas about using whatever time I have for reading, or for writing poems. I am

here for a brief twenty-five days, and I resolve to use
my time as much as possible giving myself to the
men here who need someone to talk to, someone who
can advise them about their problems, someone with
whom they can share their problems and annoyances.
I can think of nothing better to do but to try to give
myself to them and to do what I can for them. They in
the meantime shall be giving me something I want—a
feeling perhaps of being needed. It is not easy for me to
listen interminably to what essentially are repetitious
and tiresome stores, nor is it easy for me to give what I
can really call good advice. Good cheer I can spell out.
That much I can do easily. I don't want to be mawkish
and philanthropic about it. I just want to take part and
to try to give myself as a good thing in and of itself.
This is not easy, and my success I really can't judge. I
am respected, apparently, and liked; this I can feel. (O,
how often I feel dislike, have felt dislike in other places,
other circumstances!) A few, not without affection, call
me Professor, and I accept this jibe with pleasure. I may
not really be able to give it, but it is surely what the
men here need, friendship, sympathy, love. And I do
love them.

 I manage to write to Garry today. This is a very
difficult task, and I am not sure that I really will
succeed in making clear to him what has happened.
How can I make an eight-year-old understand that his
parents are in prison, and that they are there honorably,
and that he should try to feel proud and not ashamed?
How can I tell him that because of this we will not be
able to visit him on visiting day at camp, that he will be

alone? . . . I try, and the letter goes on and on—oh, this is wretchedly typical of me, of my inability to speak out clearly and simply! I have to elaborate, elaborate—the letter goes on to four pages, it is too much for an eight-year-old, but I will hope, I will hope that he will comprehend, in spite of his age and the tutelage of my parents.

I write to Rose Anderson asking her for money. She has asked please, please, to be of service, and this may make her feel helpful.

I am still without cigarettes. This is true, but what I mean is that I have not smoked for a week, and that I believe I have really stopped smoking. I never thought that I would get rid of that habit, and I must say that for one who has been tediously talking about one's duty to avoid the process of death and of embracing the seeds of life, I have been smoking much too long. I wonder if I shall ever really be free of the craving for cigarettes. I am not free of craving the taste of meat. Here it is almost nine years since I've eaten meat and I still desire it. At least once a week I would say I strongly feel the desire to eat meat. I wonder if I shall always feel that way about tobacco. Of course it is only a week, and so I am not surprised that I still feel the need.

The favor system. I am a Trusty. That means that I am fairly free to wander about the entire floor as I go about my duties. I am not responsible for my every moment's action. I can go back and forth from the kitchen to cells, and I can go from cell to cell. By slight acts of cleverness I can bring extra cups of coffee to the

prisoners, or extra servings of food, salt, soap, toilet paper, blankets. For this the prisoner is expected to give me something in return, cigarettes, candy, a pencil or comb, toothpaste, matches (in prison matches are always torn in half before being struck so that they can be used twice—matches are at a premium), paper, stamps, envelopes, etc. He might even give me a nice pair of undershorts or civilian socks for a special errand. Or a pawn ticket that he might happen to have in his wallet. No one has any money, and these are the substitutes. I carry messages from cell to cell or scavenge for a cigarette for someone who has none. I do all kinds of things, simple things, but they seem very complex, for such activity is against the law; and one is constantly risking one's good time, yet it is always done. So one gets favors. It was in this way that I got writing paper and stamps before the money came from Rose Anderson. Also candy, and I also took cigarettes and gave them to the skids who were less well adapted than I at obtaining them. I found this rather fun. We developed all kinds of ways of sneaking food back to the cells. Extra cups of coffee we carried in the slop buckets when we were cleaning up; bread frequently was slipped inside the loose bulky shirts we wore, sometimes you'd pretend to be eating something when you were really carrying it to someone else. I did as many favors as I could because I enjoyed doing them so much. It was a good way to keep occupied and to express all the hostility you felt against the system. It was like playing behind the teacher's back.

If I had wanted cigarettes at this point I could have

gotten them in profusion.

I was surprised to notice today that only a small percentage of the prisoners went to the religious services. I was sure that they would be well attended simply because they are a means of breaking into the routine. While the shift was going for the Protestant services, a plan to get me into the pen failed. Sunday morning is as good a time as any, but there seemed something ironic there.

The heat went up again today. It has been hot all week, but now it is beginning to get terrible. The humidity is high, and all day I am covered with a patina of sweat. There is ample opportunity for daily showers here, and I enjoy them enormously, though there is almost always a confrontation with a prospective sex partner, which is embarrassing and irritating, though flattering, in its fashion. One is desired

This was the day that the hack unlocked the vent in the kitchen and we all looked out.

This was the night of The Spanish Hour.

First I must point out that in jail there is almost no talk about girls or living the high life. Taboo. One guy who was brought into the cellblock on the sixth floor did whoop it up about all the girls he'd slept with and the lobster dinners he'd had. He was shouted down by the others, and — this really surprised me — the men actually called for the hack, when the guy refused to stop carrying on, and asked to have him removed to another cell in another corridor! While we were riding around in the van from one prison

to another, comments were made about girls as we passed them in the street. Really that was the only demonstrative action I had seen in this regard. But this Sunday night there was a variety show on television which held the usual attention of the men, ending with a hula-hula dance that exercised a mysterious fascination. As if hypnotized, all eyes turned toward the machine. Nothing was said, nobody cracked any jokes, but the rhythm of the music and of the dance, the unbearable sensual undulations of the dancers, the bare flesh, absorbed the attention of each and every man like a vast blotter absorbing the very life blood. The onslaught was relentless. The program was followed by The Spanish Hour, a program designed primarily for the Puerto Rican population in New York City. It seethed with the Latin rhythms, the cha-cha of the lavender and pink ballrooms with the olive skin and the superb teeth that gleam like tiaras in the middle of the face. And the mesmerized figures began to dance, at first alone and then with one another. The lust had flowered, and through this act it had transfigured itself. It had by being utterly sexual gone beyond what we know and think of as sex. It became a Liebesnacht in which the greatest of sexual climaxes is reached without the event itself. It is something we cannot understand. We can barely experience it. The exhilaration was vast, followed by the happy exhaustion that follows any great game. We went to sleep relaxed, and that night I had no visitors.

Monday, July 22 I tried to grow a beard because I

thought it would reduce my attractiveness. (I did not imagine that I would have to wait until I was thirty-two and losing my hair and be in jail in order to really become a universal love object!) The stubble which was already six days old was still apparently not enough to discourage the men who were interested. Mr. Cooper, the hack in charge of the sixth floor Monday to Friday from 8 a.m. till 4 p.m., told me to go upstairs to the barber and get shaved and get a haircut. Right above the entrance hall on our floor is a cell that has a barber's chair in it and a sink. It is here that one shaves. The cell can be watched constantly from the floor below by the hack. I told Mr. Cooper that I was going to grow a beard. He told me that that was not allowed, that I could grow a beard only for religious reasons. "Are you a Mohammedan or a Jew? Are you prepared to tell the captain that you are growing it for religious reasons?" "No," I replied. "Then go upstairs and shave. And," he yelled up, "give this guy a haircut, nice and short." Someone told me that Mr. Cooper was in charge of everybody's looking nice and neat, that that was one of his responsibilities. The barber, who was sweet on me, gave me a very nice haircut. Getting a haircut is another popular thing in jail because it breaks up the time, and the prisoners get them as often as every ten days. The barber, of course, is an inmate. He must constantly present his tools for inspection and counting. I was given a razor, and I began to shave. After the first few strokes, I put the razor under the faucet to clean it out. It was the safety razor type. I found that I could not unscrew the razor to clean it, that it was a special kind of

razor in which the blade gets locked. Things like this are both amusing and irritating to the prisoner. Every one of them gets noticed.

This afternoon we spent washing the bars. Washing the bars is one of the most annoying jobs you can do in jail. It is what I call "made work," that is, it is work that is thought up in order to keep you busy. The work itself is quite unimportant. No doubt the bars should be washed once every few months. But as a regular practice it is too much. And, as I learned, it is a regular practice. I wrote to Lester during my free time.

Today the mercury went up to 101° at the city airports, I learned (over the television newscast); and I remarked on the physical types that populated the jail. Most of the men here are young, twenty–thirty years of age, extremely muscular (the kind of muscularity you see in sculpture, even the skin looks hard), and tattooed — there were a phenomenal number of tattoos, ships, anchors, girls, mermaids, flags, tombstones saying "Mother," banners saying "Mother" or "Jeannie" or "Veronica," crosses, dragons, crossed swords, and designs obviously copied from the primitive drawings of the wearer. The population was overwhelmingly Negro. At lunchtime, when the food is served cafeteria-style, I counted the men in the detention cells; out of 240 there were thirty-nine who were white. I am sure that definite figures on this proportion can be obtained and will bear out my observations. I remember at Hart Island a newcomer looking over the long dormitory and saying, "Man, this show has an all-colored cast!" The integration in

the jails is pretty complete. There is no discrimination or segregation whatsoever, and the colored and the whites seem to get along with utter friendliness and intimacy. One beings to forget all about the difference. I used always to be conscious of talking to a colored man whenever I was talking to a colored man. But here in jail I began to forget, and I guess if I had been here very much longer, I would really have come to forget altogether. This situation — the integration — was frequently commented on as one of the praiseworthy aspects of jail, And only in jail do you find it. That is, only in a cooperative community. For that is what jail is, for the inmates at least, a closed cooperative community.

The temperature was down today to 97.6°. I keep reporting the temperature because it was stifling in that place. All night long we would wake up bathed in sweat and I, at least, literally gasping for air. That filtered air system. But, then again, if this were the thing I had most to complain of, it couldn't have been so bad.

<u>Tuesday, July 23</u> Satyagraha. This word drifts in my mind. I hardly know it. I have heard it and remember it vaguely as part of Gandhi's way. Was it the way of love? One must win over the guards, the enemy, with love. Remembering this is hard enough. Practicing it? It is such a comfort to sneer at the hack, to condescend to him, to feel superior. It is so easy to sympathize with the other prisoners. We're together. But the guards, they must suffer our scorn. They must work all day in an environment where they are disliked, mocked,

resented, hated. What can I do? I too poke fun at them, talk behind their backs, resent their actions and recount their little cruelties, their errors—for they are not often deliberately unkind. They exercise the authority of their positions. But I do not feel the love. Well, I feel the love now, two months later as I write this; but I know, I know, that I did not feel it then. Now I know more about Satyagraha. Perhaps the next time I could let myself feel some understanding or some sympathy. Perhaps they can be reached. But it is so hard not to pretend that you are something special. Everything is hard, everything.

Sometimes at night the activity in the dormitory is comparable to the traffic at the Everard Baths, a place in our city where men of Italian tastes go to spend the night.

This morning we were suddenly startled in the middle of our work by an order to drop everything and come to the "bridge" (the central corridor) instantly. "On The Help! On the double!" We lined up. As soon as we were counted, the elevator opened and out of it came, I think, fifteen hacks, the gate opened, they raced through, and we were told to undress. They were searching for contraband. Like lightning they began to go through the cells, and they knew their business. As soon as the men in the cells got wind of what was happening, they began to toss out contraband at a terrific rate. All kinds of things are made by the men in the cells. By all kinds of things I really mean raisin wine and potato wine. Raisins are served in bread and in salads. These are gathered by the men and then put in a half-pint milk container. The wax containers

can be bought daily from the commissary when it comes around, and then the top can be torn off and you have a cup to keep in your cell. The raisins sit in the water for about a week and voilà: something intoxicating. Raw potatoes are at a premium; but they are occasionally brought up from the kitchen and then cut up and soaked in water for a couple of days. There is no hot water in the cells, but at mealtime the mixture is placed in one of the metal cups and heated by making a fire in the cell out of newspaper. This is a very crazy process and requires making a tent out of your sheet to guide the smoke into the air vent. But it is done. Well, toilets began to flush, and everybody got rid of their contraband. I felt sorry for all the salt and sugar that was tossed out that I had so painstakingly brought to various men. Magazines, they too were tossed out. They too are considered contraband. I have no idea how they get onto the floor. Somehow, though, they do, and then they all wind up in a tall stack in the hacks' office, and the hacks sit there reading detective, romance, and smut publications by the hour.

Surely the Department of Correction knows all that I know and that all the others know. Surely somewhere along the line some member of the department has been enrolled in these institutions as an inmate and worked as a spy. This could be done so easily, and they could soon know all that there is to know. But of course it is possible that such a means never occurred to them. To do such a thing, to be a prisoner, is probably so terrifying to the Department of Correction itself that they might never have dreamed of placing a man in

such a position unless he had really committed a crime.
I don't know.

After the shakedown there was a terrific mess to
clean up. As the hacks went through the cells, they
threw out everything that wasn't the bare essentials
of the cell or prisoner into the corridor. We were able
to return a lot of what had been thrown out after the
squad had gone.

After lunch I was called to the front gate. An officer took
me downstairs with him in the elevator and told me
that I had a visitor. I wondered who it could possibly be.
Besides, I knew that I was allowed to have visitors only
on Friday night between 6:30–8:30 p.m. I was confused.
I was escorted into what I can only describe as a steel
phone booth and locked in. There was a small window
of glass so heavy that it looked green. There was a
telephone. Suddenly I saw my Uncle Dan, bless him,
sitting there. He also had a telephone and so we talked. I
believe we had fifteen minutes, but it seemed quite long
and might have been a half-hour. I believe he told the
authorities he was my lawyer! He was very friendly and
we joked a lot. He had been to see Judith and brought
me news of her, for which I was very grateful. But he
told me disconcerting things — things which upset me.
He told me that Judith was not doing well, that she was
being worked much too hard and that she couldn't take
it. "She ain't gonna do this next year, no sir!" he said. I
said that maybe she was without makeup and he had
never seen her without makeup and maybe that was
why she didn't look well. I pressed him with all kinds

of questions, but he stood fast until he said, "Gee, I see that I shouldn't have told you this, you're getting upset . . ." No, no, no, I protested, I want to know. But I was sure that he was deliberately trying to disconcert me, I felt that he did want to upset me. I told him all about myself, of course, but tried to be quick about it. I wanted news from the outside. He told me that my brother and my Aunt Florence had been very upset. That Franklin had to take a lot of criticism and answer a lot of questions out at his country club. That he had asked people if he could get us out, had asked lawyers, etc. Dan said that he told them that there was nothing at all that could be done once we had been sentenced; he also told them that we didn't mind and that we would be angry if they did manage to get us out. I told him he was right. Florence had said, "But we can't let them rot there in jail!"

Can one rot in twenty-five days? The people on the outside are so horrified of imprisonment that even the idea of being in jail overnight seems to the average citizen something that can hardly be borne. They believe, I think, that there is a class of people — criminals — who can bear it, but that for anyone else it is an insult and a discomfort which is more horrible than anything else in life. They value freedom very much, yet they accept the prison of conformity. It is this conformity that makes prison seem so bad. Were we more concerned with love than with conformity, we would all be in jail.

Dan brought with him, in this visit, a sense of shame. I was ashamed to be seen by him, in these gray

clothes, locked in that booth. It is strange, for I would have been at ease with a friend, but with my uncle I felt humiliated. I felt humiliated not because he accused me nor because he humiliated me. I felt humiliated because I could feel his humiliation and the humiliation my family was feeling. I could feel Franklin's humiliation at the club and his wife's humiliation before her friends. I could feel Garry's humiliation as he read my letter.

But this is the way things are. Did I expect that I could go to jail because I was protesting a world of war and that I would not be hurt? Did I think I could take going to jail and feel no twinge of regret or unhappiness? Did I imagine I was some absurd kind of superman whom I would detest were I to meet such a man? No, I was hurt, and upset, and felt a burden of guilt. I did not want to add to the unhappiness I had already caused my family. Could I do nothing of which they could be proud? Did all my non-conformism, my own craziness bring them nothing but sorrow, could I bring them no pleasure, no pride? How can I teach them the rightness, if any, in my way of life, if they cannot take pleasure from it themselves? All I do is bring grief and regret, more grief and more regret and shame to them. This I must bear.

Abstractly, the prisoners look forward to visits. But over and over again I heard the men say that the visits were very disturbing. "Oh, shit, man, I had a visit from my old lady . . ."

Dan brought me another letter from Judith, but of course he had to give it to the hack. It was good of him

to come. It was very good of him to come.

The heat wave was over today. There was a letter for
me from Agnes Bird, a friend of *The Catholic Worker*. She
included as much news as she could about the others.
I was pleased to get a letter from someone who hardly
knew me, and I answered her, telling her as much as I
could about where the others were and what they were
doing.

A new man arrived on our floor as one of The
Help. He was transferred to our floor after he got into
a fight where he was and broke another man's arm.
Apparently the other man had threatened him with a
dust pan, and P. had broken his arm over his own as
the other man brought his arm down on him. The other
man was put in solitary.

P. is a very friendly fellow, with a loud mouth and
many stories. He knows his way all around, kids the
hacks, and is very bold. He goes to work with me in
the kitchen and begins to take over. He has all kinds of
shortcuts. He was in Attica state prison for ten years on
a manslaughter charge: he had killed two men. He was
pleasant, good-natured, a little selfish and out for his
own skin and his own comfort. He would hide butter
and marmalade and other things in the kitchen so that
even other members of the staff could not get them. He
was very fond of me and pestered the life out of me for
the next week in his attempt to make it. Though he was
selfish, he did not hoard any of this knowledge and
gave all of us many hints about beating the system. He
was a good listener and never talked anyone down. He

was anxious to alter some of our ways of doing things, but we could not blame him; he was more set in his ways than we were in ours. Still, his presence was more uneasy-making than that of anyone else. He was a boss type, and his authority was not to be questioned too much. Harper, the captain of The Help on our floor, did get into arguments with him about how to serve the food and things like that. I knew that this man more than any of the others needed the friendship and love that the others were closer to. He was more alien, more difficult. His hostility was well-entrenched. I wanted to reach him, but I knew that anything I might say would be futile until I could accept his need for physical contact, that if I didn't have sex with him I would be nothing more than a psalm-singing goody-goody. And it became quite clear to me that more wisdom than I have is needed. For everything, for everything.

<u>Wednesday, July 24</u> A cool night's rest.

The colored people are anxious to be white. This was never so apparent to me as when I came to jail and saw maybe a hundred or more (more—when I think of Hart Island, far more) anxious to have straight hair. They walk around all day with handkerchiefs tied tightly around their heads in an attempt to straighten it out. Fantastic. Madness. To this we've come. The handkerchief gets knotted in four corners, and then a small knot is taken in the center of one side, and voilà, your hair is strapped down. Some of them managed to make their hair pretty straight. Integration. A situation in which values are so perverted that the Negro must

try to straighten his hair in order to feel more on an equal footing with the white. He must look like the white rather than go into himself and let the beauties within himself emerge and flourish. He is ashamed of himself, he adulates the white, rather than understands man in the world. What a mess, what a terrible, terrible mess has been made, we have made, we have made!

In the circle in which I move — the art and literary circle — it is, I think, considered a bit gauche, a trifle dull, to deal with these problems on any but the most abstract levels. They are too obvious even to be discussed.

Nobody wants really to think about these things.

The most prominent phrase in prison jargon is "mother-fucker." Or "mother-fucking." It is used so consistently that it seems that barely a moment goes by without it being said. The hacks curse even more than the inmates. They cannot say anything without cursing. Why this phrase, what does it mean? It means that it is the lowest thing a person can do in our society. It therefore means the mother-fucking food, the mother-fucking hacks, the mother-fucking dormitory, the mother-fucking church services, the mother-fucking showers, the mother-fucking salt, the mother-fucking broom, the mother-fucking blankets, hey mother-fucker!

I notice that whenever the colored boys draw pictures of girls — and they are very bad and very primitive — they are always pictures of white girls. White race is winning.

When I find myself listening to the orders of the

guard — being told to do this, do that, carry this, clean that, get this, go here, stop, start, open, close, answer, and do this work, this work, this work, I realize that I am not only a prisoner, I am a slave. I am not just being kept locked up, but I am being made to work. I understand that one of the problems of the penologists is that of keeping prisoners busy. Is this, I wonder, part of the rehabilitation program? The issue is confusing. Is it worse to keep men locked up all the time in a cell and not permit them to do work or to force them to do work, a great deal of which is absolutely useless? The issue has innumerable sides, innumerable possible repercussions. One wonders, where does punishment leave off and rehabilitation begin? Where does the Calvinistic idea of production take over, at what point is society delivering the real blow and making a slave of the prisoner rather than simply keeping him locked up? Is society trying by forced labor to make the prisoner feel less resentful toward the work of the world? Is the prisoner supposed to begin to enjoy work while he is in jail? The work is not of that sort. The attitude toward the work is certainly not that, certainly not on the inmates' side. They resent it. But most accept it, because they couldn't possibly imagine anything else. They know that it is the way of the world to make one work, you always have to work, if you don't work you starve. Not only are we prisoners, but we are slaves. Well, we were always slaves. That's the way life is.

The entire prison system is rotten, the very idea of a prison is rotten. It is absolutely mad of me — no, it

is absolutely bourgeois of me, it is a result of all my bourgeois background – to expect that there might be some rehabilitory value in prison. All that prison does is to deepen the hostility of the men toward the world in which they have been captured. The altruistic love that is expressed and felt in prison? Ah, that is something that is only a sign of what can be. It is something that I am afraid is not an aspect of men who are criminals, it is an aspect of men who are suffering. In order to counteract the suffering this love is expressed. It is in everyone. But the outside world does not know it is suffering.

That is why we must teach them. That is why we have naturalism. That is why we have the realists and the muck-rakers, the journalists who expose and the scientists and sociologists who show us things as they are. That is why I want to make the paintings ugly and cruel, fierce and disgusting. I want people to see that we are living in the last judgment. This is it, now. I will hold up a mirror, not of our aspirations, nor of our daydreams, nor of how we want to believe we are and feel; yet I will hold up a mirror of our dreams and of our homes, of our heroes and our ways. But all the same, the pictures will say, and the poems too that I shall be writing, that it is all the same, the god that does not exist loves everything, there is nothing that is not worthy of being a great painting, there is nothing that is not love and beauty. When this is grasped, ah, well, then the pictures too shall be grasped (for they shall be strange pictures).

O muse, o muse, aid me, aid me. I cannot envisage

success, only failure, I cannot achieve what I dream of achieving, the pictures will not look that way, nor the poems, nor do I even have courage nor conviction to try to do what I dream of, aid me, aid me.

I am disappointed that I have not gotten a letter from Claude. I was sure that he would write. Perhaps he does not know, so I write to him. Also to Mr. and Mrs. Sleeper, the people who run Garry's camp, explaining why Judith and I shall not be there this weekend.

The hacks do not carry guns. On Hart Island they did carry rubber truncheons, but not here. A gun inside these walls would be only dangerous. All the world's a prison, and a gun anywhere is dangerous. When has a gun done good?

Thursday, July 25 I write again to Judith, Garry, and Lester. Five dollars arrive from Rose Anderson. There is a procedure for receiving a money order. A hack whose job it is comes up to you and says, "Are you expecting a money order, from who, what is his address, what is your name," etc. When you have sufficiently identified yourself, you sign the money order and a receipt, and the money is deposited in your account. The officer who asked me these questions said, while I was signing, "You're very well-spoken, are you a college man?" "Yes," I replied. "Where did you go?" he asked. "Yale," I replied. He asked me then what I was doing there, I explained, and we argued for about fifteen minutes. I told him about myself, who I was, what I was, and spoke fairly well. But so did he. "Wouldn't it

have been better," he asked, "to have spent these thirty days just going through the city and helping the first person you might meet who needed help? There are certainly enough such people." "There are people here who need help. The whole world is in need of peace." "Julian Beck," he said, looking at the money order, "I'll remember that." "What is your name, sir, if I may ask?" "Allan Schwartz. Uh . . . I'm really not in the Department, I'm a social worker, and I'm doing research in penology, that's why I've taken this job, for research . . . Well, it was very nice meeting you, I'll have to go now, good luck." And I wondered again if there were any penologists among the prisoners.

A special hack came to me today and questioned me as to my correspondence with my wife. Evidently Judith had not received any of my letters yet and asked the social worker why she had not heard from me. Something else to fret about. The letters have to be censored on both sides, here and at the House of D.

In the evening I write to Robin and Alex.

Friday, July 26 Got commissary at last. Dan had deposited five dollars in my name when he was here, and Rose's money too was working. I got paper and envelopes and candy, a comb, a pencil.

Three of The Help left the floor today to be released, and there was a great deal of well-wishing, and a certain amount of sentimental leave-taking. I begin to give myself more and more to the other inmates and find myself employed writing letters and being asked for all kinds of "serious advice." All those men

standing trial, day by day not knowing what will happen to them, some of them facing such long and terrible sentences. The anxiety is awful, and I reflect on what a blessing it was that we were tried and sentenced so quickly. Most of the letters that I write are love letters to wives and sweethearts. "Dear one who I love, I love you so very much that I hope you are not feeling too badly about all this. I am so happy to know that you are sticking by me. How can I tell you how much you mean to me? It is very lonely here, and I think about you so much and all the good times we have had. Your eyes are like diamonds, and I can see them now staring at me all full of love . . ."

The onion-faced hack who is on duty now is one of the ten percent who are nasty. At night he goes around on tiptoe toting a bucket of boiling hot water, which he throws suddenly into the cells of men who are talking after the lights have been turned out. This is rotten, because it soaks the blankets and pillows, etc. He has been instrumental in the latest food problem. They just are not sending up enough food from the kitchen. What used to be sufficient for 180 men is no longer sufficient for 230 men. In the past whenever we have run out of a certain dish, we have been permitted to send downstairs for more, and it or a substitute has been sent up. Now we are told to be sure to make whatever we have last, that we will not be sent additional food. One tablespoon of applesauce for dessert for each man, one tablespoon of scrambled eggs, "The warden says feed the men on bread!" I realize that if this condition continues long enough, it is the kind of thing that leads

to strikes. But this is a house of detention, not a regular prison, and the men here might not act that way.

It is getting so that I look forward to letters with terrible desire. It is awful, and I wish I could stop it. Some days I have managed to work through this feeling by getting a real understanding of the reality. That what I did was a small thing, that I must do such things without expecting any gratification, that I must not expect friends to send me letters, I must not seek praise and things like that, that even that spoils the act, which I do not want to do. But still I crave some letters. The time in here is long. But out there it is short. How quickly time passes on the street. Two weeks is nothing. Nobody might know . . . There is a letter from Garry in which he says, "Dear parents, even if you can't visit me on visiting day, can't Lester come and see me? Your son, Garry." That is all. That is all. Tomorrow is visiting day. There is nothing I can do. It was wrong, wrong of me to expect this much of him. How could I have thought he might understand, how could I have entrusted him so much into the hands of my mother? But then, I like myself. Ah, but she is no longer the same, she will not influence him as she did me, but use opposite methods. She does not want him to be like me.

This afternoon at Hebrew services there were twelve men. After racing through what was already a streamlined version of the Friday night services, the rabbi read us the Jewish news events of the week. Miss Universe was chosen in Long Beach, California. A Peruvian Jewess. This is no small triumph, so her picture is passed around from man to man. A few

more stories about its not being good to steal, and then a strange one about a Polish girl who is given to a Christian family by her Jewish parents because they are afraid of extermination. The girl is raised a Christian and becomes a rabid anti-Semite. In her high school she is the leader of pogroms. She fiercely insults a Jewish girl in the school and spits on her. The Jewish girl is driven to distraction but finds out that the other girl is Jewish also. So she tells her, and the girl who was so anti-Semitic goes home and asks her parents, and they tell her yes, she is Jewish, and the next morning she is found in the river. "And so," said the rabbi, "you see what happens." He then played some Jan Peerce records while he collected his yarmulkes.

I write to Walter Mullen[12], Garry, and Judith. Kieran is visited by Charles MacCormack, who brings news of what is going on in the House of Detention. While waiting to be locked into his booth, Kieran sees Mike and Sandy. They are still in the Tombs and are working at the House of Detention. Mike saw Dorothy and spoke with her. Judith is all right.

<u>Saturday, July 27</u> This day I am tormented by remembering that this is visiting day at camp and that Garry will be unhappy. I dare not imagine how unhappy.

While I was not fretting about this I was looking

12 A student with Judith in Piscator's Dramatic Workshop, Walter Mullen played the title role in the Living Theatre production of T. S. Eliot's *Sweeney Agonistes* at the Cherry Lane Theatre in 1953 and acted in Paul Goodman's *The Young Disciple* at the 100th Street loft.

forward to going on the roof at night. But it rained and we did not go.

I talk a great deal to the men, but I cannot think of anything yet to say about these talks.

Sunday, July 28 The days are all alike, there is no difference. Lightless, airless place. It is beginning to cloy. I wish I were not here. The pleasure of adventure has worn off, and I do not know what to do with myself anymore; I am getting bored and irritated. I am not sorry, not at all, but I want to be out.

I have a persistent cold. I caught it at the end of the heat wave. Everybody seems to have it. Debilitating. Makes the work harder. I write today to Willard and Marie Maas[13], and to Rose Anderson. Under a compulsion to write letters.

Monday, July 29 It looks as if the days are going quickly now, but that is not true. They are going more slowly, but there is less to write. They are going more slowly just because there is less to write. There is less that is new, there is less that is interesting anymore.

I write today to Judith, William Marchant[14], Dick Kern. And there are letters from Claude, Marius Bewley[15], and Lester. Lester was also thoughtful enough to forward mail from home, from James

13 Willard Maas, a faculty member at Wagner College in Staten Island, and his wife, filmmaker Marie Mencken, knew everyone in bohemian circles.
14 Playwright known for *The Desk Set*.
15 Literary critic, professor of English at Rutgers University.

Waring[16] and my mother. I keep rereading all the letters like a madman. As if they were love letters. Over and over and over again for days.

<u>Tuesday, July 30</u> After breakfast I was called to be transferred back to Hart Island as a preface to discharge. We had expected to be sent back there on Friday, and this is really too much of a pleasure. I was actually getting quite upset by this place. Also the pressure on the homosexual issues was getting severe and difficult. I was beginning to be afraid of being really forced, and too much unpleasantness was developing over the whole thing. I keep imagining that I haven't handled it properly.

It is a warm day. After breakfast a guard comes and we say goodbye, and we are taken back to the dormitory and get our belongings, and then on the elevator on the way down to the main office we are joined by Mike and Sandy, among others. We are handcuffed together, and then! — into the radiant sunlight. Into the exquisite dawn like a lovely silver girl in sandaled feet. We were put into a bus this time, not one of those dreadful vans. It was more than I could hope for. And we traveled all the way from lower Manhattan to Hart Island at the other end of the Bronx in a bus that you could see out of, even though the windows were barred. How marvelous the city looked! Oh how ashamed I was of myself that I had ever really fallen for that line that New York is a place

16 Esteemed choreographer active at Judson Memorial Church.

of unmitigated evil, that only the country is nice. There can be errors and yet be splendors. And New York is splendor, a testimony of man's power to build a place to live and work in, so full of ghastly errors and so beautiful. And the people. It was like a religious ecstasy. We drove through Greenwich Village to the House of Detention, for some reason, and then back through the city as it made its way to work and we to our island.

Then came that induction room. This was the time that the man went mad with fear that something terrible was going to be done to him. He was the first who was told to undress and be sprayed; and he was filled with fear. And the worst part was that not one of us was brave enough to say to him, Look, it's not bad, just do what they say, take a shower, that's all, everybody does it . . . But none of us had that courage, and the man tried to fight the hacks, and they tied him hand and foot, took off his clothes, and he squirmed around like a serpent on the floor for about ten minutes—everyone horrified and no one daring to comfort him—until they finally brought a blanket, which for some idiotic reason wasn't readily available, and they covered him and carried him away to an isolation cell.

I was put with the mess hall gang. That night I washed pots and pans. Sandy and Mike were again sent to the same dorm and put in with a labor gang. Kieran was put with what is known as the house gang—they clean up the dormitories for those who work on other details.

Last night there was a reunion on the ball field —
Ammon, Dick Moses, Dan O'Hagin, Mike, Sandy,
Kieran, myself. Carl Meyer still on Riker's Island. It
was so wonderful and I enjoyed it so much! I was told
that I would be put on the a.m. shift in the mess hall
and would not go to the ball field at night, and this
distressed me terribly.

I realized that there was something to be said in
favor of prisons that are in the country, open, with
trees, sky, fresh air, a game field. I don't think any of
The Help at The Tombs feels particularly unlucky or
wish that someone else had been sent there instead
of themselves. Many of them perhaps don't feel the
difference. A couple said so to me. They didn't think
much of Hart Island. But I did. I loved watching the
boats from City Island and bathing in the late afternoon
sun.

In this dormitory the homosexual situation did not
differ one jot from the situation in The Tombs. The first
night I was "rushed." The same kind of business, the
same refusals. Awakened again and again during the
night, no, no, no. I felt like a son of a bitch. Really, I
felt like I should be cooperating, it seemed so right, so
natural, so normal.

Wednesday, July 31 I am put onto the a.m. shift. We
rise at 4 a.m. and are on our way to work at 4:30.
The constellations are still in view, and large, heavy,
gorgeous, the morning star hangs in the east like a
promise of love—a promise, not a memory. We eat,
and then at 5:30 the others arrive, the other 700 who

populate this island.

I am put in the dishwashing section. I seem to have a propensity for being put in this department. I will soon be King of All the Dishwashers. I am now one of those who make the horrendous racket that greets the eaters as they walk into our beautiful mess hall, which I will mop after the breakfast dishes are done. I and another fellow stand behind a sink, and as the inmates leave the hall, they bring us their dishes and we hand-wash them in a big, sloppy, soapy sink. This is not bad, because at this job I get to see at least half of all the prisoners. The other half go to another dish window. I see all my pacifist friends and smile at them. It gets very hot here, and we work very fast, so once again the sweat pours off me in rivers, and Mike Graine winces every time he sees me. He and Sandy have been put in what is called Labor Gang II, and from what I gather, they don't do very much. So as it turns out, I am the one who is doing the most work of any of us. I take this as kind of an honor. After all, if there is going to be some penancing for that Hiroshima bomb, somebody ought to do some work. Now, I have always liked working hard whenever I do work—I like to feel a little pressure—so I don't mind this work at all. I am in fact pleased with the opportunity that this stretch in jail has given me, the opportunity to do a little work. My poor body has been leading such a sedentary existence ever since the theatre closed; in the last two years the only work that I've done at all was when we were working

on those Kupferman operas[17]. This work is rather different, though; the difference between dirty prison dishes and operas naturally is amusing.

Ammon stayed in that hostel for old men about a week and then got transferred into Dorm #2 and now works two hours a day in the commissary. He apparently does his job very well and is liked. I hear, though, from boys in my dorm that he is not liked by the inmates because he doesn't like stealing in the commissary. I question him about this, and he says it isn't that he doesn't like it, but that he doesn't do it himself.

After the mopping is done we sometimes get a bag of Bull Durham for our labor from the hack in charge. This happens about every three days. Ammon gets $2 a week for his work in the commissary — not in cash, of course, he is allowed that much purchasing power.

Here on Hart Island I have to stop writing letters again because I don't have the right stationery. Here you are only allowed to write one letter a day, but you can still get as much mail as is sent to you. Here you write on special stationery that makes you look just like a convict. That is, after all, what we are.

After the washing and mopping I go to work in the kitchen preparing lunch. All the food is prepared by the inmates. I fry fish, make meatballs, cut roast beef, peel onions, etc. That onion-peeling bit was interesting. I think we peeled (four of us) four bushels. You cry

17 The Living Theatre had considered staging Meyer Kupferman's operatic settings of Gertrude Stein's *In a Garden* and Alastair Reid's *The Curious Fern*.

bitterly for about three minutes and then you don't cry anymore, and you go on and on and the onions don't affect those tear ducts at all anymore. That impressed me. I had never thought about it before. Onions must be peeled and that's how. Potatoes are peeled in a machine.

As a result of the ill-fitting shoes I wear, a huge boil has developed on my foot. It had become quite ugly so I broke it myself under hot water, and it is healing very nicely. I wear the shoe with the lace so loose that it is like a floppy slipper. I have been sick when I have not been in jail.

I borrow stationery — Ammon brings me some — and I write to Judith.

I go again to the recreation field after supper. I went there after lunch today — my workday lasts from 5 a.m. till 1 p.m., and after lunch our shift was sent out to the field. Then this evening a new hack was on duty and sent us all to the field again. I was filled with joy, for I did not think I would have a chance to be together again with my friends; but somehow — I keep imagining it is because of my wishing it so much — I am again on the field with them.

Thursday, August 1 A new month is a big day in jail. Everyone talks about it. Everyone is counting, and a new month means that a new batch of people are less than a month within release time.

It is here in jail that I begin to understand Genet and his play "Death Watch," which I certainly did not understand when I read it.

Here in the dormitory there are spaces between the

edges of the window grills. Sparrows build their nests under the ledges, and they fly right into the dormitory. As I sit on my bed writing letters I can see them across from me, walking and flying about. They will be able to go outside, of course, and they are a bright symbol.

I am speeding now. I want to get out. I want to get finished writing this record. It bores me. Jail bores me. I can hardly wait. The days creep. There is so much that I want to do when I am released. And yet I do not know what I want to do. I feel so deeply that the Life of Art cannot really fulfill me any longer. Yet I do not know what will. I hope perhaps that Judith will know. She is so wise that way, and her original and inventive mind thinks of these things. I can do, I can follow, I can invent after I have been led into the room. I am secretly hoping that she, like me, feels this need, this calling—it is like having a rope around your waist that tugs at you—will I cut that rope?—I wonder is it tugging her?—will she cut that rope, has she cut that rope? She is so devoted to being an actress. And I. Am I a painter, a writer, a stage designer, what? I don't know. I do know that I have never never received so much satisfaction from anything that I have ever done. All I need to do is to think about it to realize that this is true. Every time I reflect, this is so, it is clearer and clearer to me. Everything except perhaps Garry, and my life with Judith. For those things are real.

Of all the people I was imprisoned with, next to Ammon, the one I want most to write about is Sandy Darlington. He looks like his name, he is red-headed, a

kid, freckled, charming. He comes from Seattle but has a
lot of California in him—he went to school there. I want
to write about him not because of his intelligence nor his
charm, which were altogether evident—but because he
seemed to me so strikingly representative of the youth
of our time. He made me realize that I was a decade
his senior. He made me realize this not because he was
more youthful than I—though I'm sure he was, though
he was a bit slothful—but because of his attitudes and
ideas. He is well-read and perhaps not without talent
for writing. His taste seems good. He has a smiling,
glowing face and an even temperament, a good sense
of humor, and a sense of the sardonic. But the funny
thing is that he is disengaged. He maintains that he is
engaged, that everything goes, that all things are equal.
He likes reality. He dislikes decorative painting—he is
calling the lie about it—and has some healthy scorn for
the decoration in the New York Abstract Expressionist
School—for Pollock, Motherwell, Baziotes. He listens to
me attentively when I talk, but his approach, which is
without hope, which is without programme, is, despite
all its attractiveness—on him it's attractive—very glum,
very discouraging. He takes part in our air-raid thing
not with fervor but simply because the whole air-raid
drill biz seems a lousy thing to him. There are no moral
involvements, no pacifism. What's the use of fighting?
You shouldn't bother yourselves with that kind of stuff,
there are other problems . . . There is a freshness about
him, and maybe his iconoclastism will bear fruit. Maybe
he will destroy some of the false gods. A funny boy. He
embraces everything, yet he seems sad, sad because he

seems empty, empty because he has no enthusiasms, no hope in anything — no lack of hope — no interests, no fervor. It is the quality of the human being to be very human that makes him divine. When the human being enters the Kingdom of Heaven he is an angel, and when he passes into Nirvana he is a spirit.

Mike Graine is an actor and an anarchist and an atheist. These things you find out about him within the first five minutes of knowing him. He reads constantly, compulsively, all the books, old and new — mostly new. But he learns nothing. He is a bit of fool. He is attractive looking and very vain. He has a good sense of humor and has very high spirit. I did not know at the time — I have found out since — that his girl, his wife, was at odds with him for taking part in this thing and leaving her for this, and that she did not write to him all the time he was in jail. He is very winning because he smiles so much and takes himself so seriously. You can't dislike him for being so dumb because he is really not rigid; and his candor — he is quite candid — is not so much disarming as prepossessing. Perhaps someday all the books will suddenly coagulate into a moment of understanding and consummation and Mike shall emerge really thinking.

Kieran I find almost impossible to write about. He is not at all my kind. Yet he and I were closer — we were together for two weeks and away from the others — than any of the others. We were able to talk to each other with instant understanding. We communicated perfectly and never told each other things the other

did not wish to hear. We were both interesting and helpful to the other. Yet this young man who for over a year was a novitiate in the Trappist order — and who found their training program much harder to take than being in jail, but stuck out that first year and left only after it was over! — was in a world I could not enter. I think very highly of him. But still I cannot write about him. I do not understand him, I do not understand the religious impetus that governs his life. But this too I must add, that if I were to get to understand him and to know him, to really know him, I am sure it would be a rewarding experience. He is a gentleman of value.

<u>Friday, August 2</u> Looking in the wastepaper basket I see a discarded *New York Times*. A hack must have brought it with him and thrown it away. Otherwise I cannot explain its presence. Since there is no daily commissary on this island, newspapers are not sold. How they get here, and they do, I do not know. What inmate subscribes to it? It's amazing the number of things I don't know. There doesn't seem to be that much to learn. Here it is three weeks since we were arrested, and still there have been no official lessons. No "orientation" lecture. That probably happens in the long-term institutions. Well, anyway, in this *New York Times* there is a long letter to the editor about us. There is a letter signed by the editor of *Commonweal* and Rabbi Feldman, I think, of the Jewish Peace Fellowship and someone else saying that our imprisonment shows lack of respect for the freedom of religious expression, etc. I am not particularly in agreement with the letter but

am delighted to find it and to think that there is some attention being paid us.

Despite all that I may say about doing this thing purely for myself, I am very interested in all the publicity this action gets. The more the better. As a matter of fact, when I get out of here I intend to write as much about this as I can, and get as much published as possible.

Why did I do this? Because it is more important than anything else I could do. Our lives are at stake.

The letter is from Tuesday's newspaper. I show it to some of my friends, and they pass it around, all reading it with interest. Many of them argue or discuss my position with me. Almost everyone comes over to our way of thinking very quickly. They are all sympathetic except for two who insist that we must be communists.

Though they did not come across any incidence of homosexuality in the third-floor dorm of The Tombs, both Mike and Sandy are having their troubles now. This information comes to me with some relief, for I had, of course, begun to believe that my attractiveness was caused by my effeminate characteristics. This did disturb me. I knew I was cultivated in my manners, I behave in a somewhat unusual fashion which is now automatic to me, though it was for years cultivated, and I am no doubt a little weird, poetic, perhaps, misty — but rather I like to behave with strength in my gestures. I was disturbed by being so attractive, but now that the others are being solicited (for they are "masculine" enough for my taste), I begin to think that

perhaps it really is only a matter of boyish appearance, and that makes me feel flattered.

One thing that is very nice about Hart Island is that every morning when you get up you can hear the cock crow. This is a fantastic sound I never before heard. Trumpet of the dawn indeed.

<u>Sunday, August 4</u> Yesterday is gone into the sameness of days. Today it is raining, a slow, steady rain. Tomorrow we will be released. But of course it will be raining tomorrow. I have waited for this day and had imagined sunlight and facing the world all bright and full of splendor, but no, it will be raining, sad and dreary, as the world is.

<u>Monday, August 5</u> What do the details matter now? It is no longer important how we were released and what the bus was like, or how we were kept in cells until the last minute. Into the sunlight we walked. It was a bright, cool, sunny day. The dear social service worker arranged to have Judith uptown in the Bronx to meet me. I was the first one to be discharged. The next ones were the other pacifists. The officer in charge of discharge asked me their names. Carl Meyer was there. We all flooded the world. We were sunlight added to sunlight. What is the Life of Art? Judith is there, looking beautiful and bashful. We embrace, yet we are beyond embrace. We embrace because it is the only thing we can do, yet it is not enough. Nothing is beyond enough.

The Life of Art is behind me. Yet as I write this I am in my studio — two months later — surrounded by new

paintings, on the phonograph I am hearing Saville Clarke's music for our *Phèdre*. We will have a theatre soon. I am sure of it. I am sure of nothing. The voices of Garry and his friend echo through the house. Who can be sure of anything? We do what we do. But love. There is no transcendence in anything but love. It is beyond compare.

Life is vicissitudes. The rhythm always changes and always does not change. What I am today I shall not be tomorrow. I do not know where I am nor where I am going, but I am trying to get there. The way is the way of love. The diversions are infinite, yet each diversion is in itself a way of love if you can only know it. To know that what you are doing is an act of love, and is love itself because it is life itself, that is a difficult thing. It is comprehension, the kind of comprehension difficult to attain. Even now as I struggle here at this typewriter hoping to find some conclusive words that will guide me in the future, hoping to clinch this adventure with a phrase of universal wisdom that will sustain me throughout my days, I find myself failing only as I suppose I always shall, struggling and discontent with everything and with myself.

October 6, 1957
New York City

Afterword
by Garrick Beck

I was at Camp Wamsutta, an outdoor activity
summer camp in Massachusetts, when the letter came.
Although it was my second year, I was still in the
youngest cabin. Mail was brought around after lunch
while we were in our cabins for rest period.

The long white envelope was return-addressed
strangely in penciled hand-printing: my father's
name in the upper corner, just below that the words
"6th Floor Help," below that a return address I was
unacquainted with.

I went to my bunk to open it.

And read it. A long, carefully pencil-printed letter.
Indeed it was from Julian, my Dad, informing me that
he, and also Judith, my Mother, had been arrested for
protesting nuclear tests and nuclear test drills and as
a result . . . wouldn't be coming to see me on Parents'
Visiting Day.

He wrote about the nonviolent, peaceful nature of
the action. He wrote about why people had to protest
peacefully and why the nuclear bombs were a colossal
disaster for humanity. He wrote about how important
it is for people to speak up when they know the
government is doing something seriously wrong.

But it was the part about not coming on Visiting
Day that really hit home. Everybody's parents came on
Visiting Day. I read the letter again. I lay down on my
bunk with the letter refolded into its envelope but still
in my hand. I just kept very quiet.

Believe me, from that minute on I knew that our government could easily do the wrong things. If it could do this to my kind parents, who knows what it might do with those nuclear bombs.

But all the understanding in the world couldn't bring them out of jail to come visit. It was plenty that they were beatniks, who came to Visiting Day at grade school in sandals and blue jeans. Scandalous. Beatniks! But this was a different matter. They couldn't come because they were . . . in jail.

Camp Wamsutta's founders and directors, Sam and Leah Sleeper, called me into their house a day later and were very supportive. But still.

I talked with my friend Gerry Milsky, who like me was in his second summer there. I could do the parent/kid activities with him and his parents instead of being the only kid walking around by himself. The second day, George Schwartz and his parents let me tag along.

But the experience changed me forever. I have ever since been mistrustful of governmental authority, of the usefulness of jails, of the justice in our courts, and of course, of the testing, storage, and use of nuclear weapons.

And what good may have come of these arrests?

The protest that Julian writes about in these chronicles continued year after year. And year after year it grew and grew. Thousands, then tens of thousands of people peacefully disobeying the order to take shelter underground. The government couldn't stop it. And so . . . the city-wide shelter drills came to an end.

But something else happened too. People magnetized together, meeting each other in these yearly acts of civil disobedience. And from these meetings grew much of the next generation of anti-war protests. The Fifth Avenue Peace Parade Committee, the Women's Strike for Peace, the Committee for Non-Violent Action, and many more of the most activist anti-Vietnam War groups had their seed planted at the shelter drill protests. These morphed naturally into women's rights organizations and civil rights protest groups on through the '60s and the '70s as well.

So from small beginnings do widespread changes grow.

CPSIA information can be obtained
at www.ICGtesting.com
Printed in the USA
FSHW011745040221
78217FS

9 780998 279350